PAPER CUT

CARDS

*30 stunning handmade cards
with eye-popping 3-D designs*

EMILY GREGORY

A QUINTET BOOK
First published in the UK in 2016 by
Search Press Ltd.
Wellwood, North Farm Road
Tunbridge Wells
Kent TN2 3DR
United Kingdom
www.searchpress.com

ISBN: 978-1-78221-386-4

This book was conceived, designed and produced by
Quintet Publishing Limited
4th Floor, Sheridan House
114-116 Western Road
Hove, East Sussex BN3 1DD
United Kingdom

Designer: Tania Gomes
Photographer: Lydia Evans
Art Director: Michael Charles
Project Editor: Cheryl Brown
Publisher: Mark Searle

Manufactured in China by 1010 Printing International Ltd.

10 9 8 7 6 5 4 3 2 1

CONTENTS

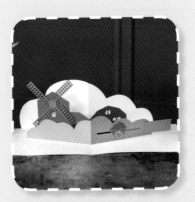

PROJECT
SELECTOR

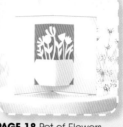
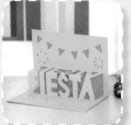

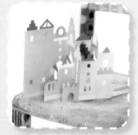

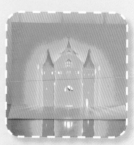
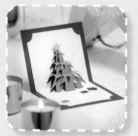
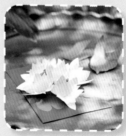
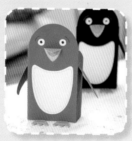
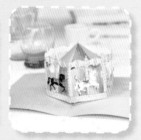

 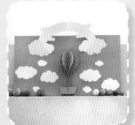

PAGE 59 Ocean Tunnel **PAGE 61** Snail on a Leaf **PAGE 65** Hot Air Balloon **PAGE 67** Daffodil

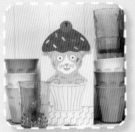 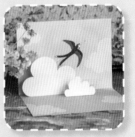 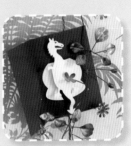

PAGE 71 Cupcake Kitty **PAGE 74** Let's Travel **PAGE 77** Yellow House **PAGE 81** Flying Swallow

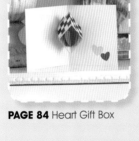 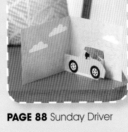 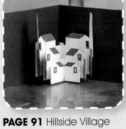 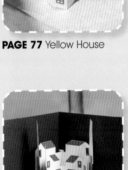

PAGE 84 Heart Gift Box **PAGE 88** Sunday Driver **PAGE 91** Hillside Village **PAGE 94** Winged Dragon

 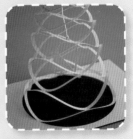

PAGE 100 Exploding Robot **PAGE 104** Spinning Flowers **PAGE 108** Dutch Windmill **PAGE 113** Bird in a Cage

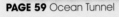

INTRODUCTION

Pop-up cards are not a new phenomenon. In fact, many of the techniques have been used for hundreds of years. The first pop-ups in books date back to the 13th century when they were used to teach anatomy and demonstrate astronomy, among other subjects, but it was not until the 19th century that pop-ups were designed to entertain, make magic happen and bring stories to life through the use of a third dimension.

Pop-up cards have developed as a simplified version of pop-up books, as they are usually contained in only one folded page. The surprise of opening a card to discover an image or a scene leaping out at you is hard to beat. To be able to create a pop-up card that bursts open with unexpected life is both hugely satisfying for the maker and incredibly special for the recipient. They are a gift to be treasured.

This collection features thirty card designs to help you develop your pop-up card-making skills. There is a wide selection of themes for you to choose from, suitable for many different occasions. There are fun and playful projects to amuse the children in your life as well as some sophisticated and sculptural designs that will stand the test of time. As you move through each chapter, you will find that the designs become a little more challenging, but with accompanying templates to copy, print, or trace, plus simple step-by-step instructions that lead you from start to finish, all you need to succeed are a few tools, paper and cardstock, and a little patience.

If you are left wanting more after you complete all the designs, then it may well be time to begin creating your own. The projects have been developed to explore the key pop-up techniques and will give you a solid foundation to adapt the card ideas to make almost any design you can dream up. If you still want to take it further, then the best advice would be to buy a pop-up book or card and take it apart to discover how it was made. Your pop-up journey begins here and I hope it will continue far beyond. Good luck and have fun!

BASIC TOOL KIT

There are just a few essential items required to make pop-up cards, and most are affordable and readily available. A good art store should have everything you need, including a wide selection of papers and cardstock for you to choose from. Most of the projects in this book can be completed using the basic tool kit outlined below, and any additional materials required will be listed at the beginning of each project. Access to a photocopier will be required to enlarge your templates to actual size.

Pencil When transferring templates on to your paper or cardstock, or when marking guidelines, use a relatively soft pencil such as a 2B pencil; this will ensure that an unsightly indentation mark is not made.

Eraser A clean eraser with sharp corners will allow you to neatly and cleanly rub out any pencil guide lines. Alternatively, use a malleable eraser that is able to be shaped to blot out any pencil marks neatly – this type of eraser is especially good for removing pencil lines from delicate parts or from paper cut elements.

Self-Healing Cutting Mat A self-healing cutting mat will both protect your tabletop and prevent your craft knife from slipping when you are making cuts. Cutting mats are available in a range of sizes, but you should choose a large one that is at least 297 x 420mm ($11^3/_4$ x $16^1/_2$in) or larger. Often cutting mats will be marked with a ruled grid that is useful for lining up layers of paper and for ensuring straight edges.

Craft Knife or Scalpel A comfortable and sharp craft knife is one of the most important tools of all for the pop-up card maker. You should avoid the snap-off blade variety, and choose one with individual, replaceable blades instead. Change the blade on your cutting knife regularly as paper quickly blunts, and you will find that the quality of your cutting will suffer if your craft knife is not sharp.

Scissors Any fine and precise cutting is best done with a craft knife, but if you do prefer to use scissors, or if you need to use them for any small details, then a sharp-pointed pair with small shafts is recommended.

Embossing Tool When you need to mark out fold lines in delicate areas, such as on the Christmas Tree (page 43) and the Medieval Castle (page 41), an embossing tool is very useful. It looks a little like a pen with a metal ball on the end and comes in various sizes; choose your size depending on how fine your folds are or how thick your cardstock is. Another option that is almost as effective is using a ballpoint pen that has run out of ink – so as to not make a mark on your paper, of course!

Metal Ruler Always use a metal ruler rather than a plastic or wooden one. A strong metal ruler will keep your lines neat and will help you to avoid any craft knife slips that could cause nasty injury. A small, narrow 10cm (4in) ruler is useful as well as a long one.

Bone Folder Usually made from the bone of an animal, but also available in plastic, a bone folder helps to crease and neaten your folds. It has a pointed end that can be used for scoring lines before you fold and a flat end for pushing folds flat, but if you don't have one, a blunt and rounded butter knife will have a similar effect.

Carbon Paper and Tracing Paper Either of these materials can be used to transfer your enlarged template on to cardstock. Carbon paper works by depositing ink on to the card when it is impressed. Tracing paper is a translucent paper on to which you can trace the template (see Using Templates on page 13).

Invisible Tape This is a low-tack tape that is great for attaching templates to paper or cardstock. Alternatively, you can use masking tape or adhesive putty to keep your template in place when cutting it out. However, be sure to test the tape on a scrap of the paper or cardstock first.

Glue A tacky PVA glue is best for sticking small pieces of paper or cardstock together. Apply just a small amount – your paper may buckle if you use too much – and wait until it has dried and bonded before you move the card. A glue stick is another option, but the bond is not usually as strong, and over time your paper may come apart.

Double-Sided Tape This adhesive tape is sticky on both sides, so it acts as a substitute for glue. The advantage of using tape as opposed to PVA glue is that your paper or card will not become wet and warp, which makes it particularly good for joining large pieces of paper or cardstock together. It is, however, tricky to work with for small areas or for intricate details. Position the tape along the edges of the page so your edges are bonded flush, which will keep them from peeling open.

Tweezers A pair of tweezers can be very useful when attaching small pieces of paper in place, such as the windows on the Yellow House (page 77), or for holding delicate pieces together to be glued, such as the snail shell circles on the Snail on a Leaf (page 61). The best kind of tweezers are those that come to a fine point at the end.

CARDSTOCK AND PAPER

When choosing paper, you need to consider thickness, surface type and colour. Paper is measured in grams per square metre (gsm), which relates to the thickness. Cardstock is a term that refers to a heavier type of paper with a higher gsm. Most projects in this book recommend using a regular to heavy cardstock of about 160gsm, which is generally the weight of an average greeting card. It is difficult to cut delicate paper cuts from heavier papers, while a thinner paper may not support its own weight when standing upright. You also need to choose from textured or smooth paper stocks. If you are printing a design directly on to the card, a smoother surface will hold the ink better. However, some card designs benefit from being made with a more textured paper as it can add interest to the design. It is best to visit your local art store and try a few different kinds.

BASIC TECHNIQUES

As you move through the projects in this book, you will gain new skills and become more confident in your card-making and paper-crafting abilities. There are a few general techniques, however, that require specific attention in order to master the art of making pop-ups.

CUTTING

When cutting the cardstock for any project in this book, always work on a cutting mat. Make sure your craft-knife blade is sharp and that you have a metal ruler at hand for cutting straight edges. Hold your craft knife as you hold a pencil, at a 45-degree angle with your index finger supporting the top. Always cut towards your body rather than away from it to give yourself more control.

The key to smooth, safe cutting is to avoid pushing down too hard on the cardstock, as this will only make it feather at the edges; aim for a smooth, slow glide and change your craft knife blade often to achieve this.

When cutting through two or more layers simultaneously (for instance, neatening the edge of a card), cut against a metal ruler and go over the line a number of times; if you want to achieve a sharp, neat edge without any tearing strains, don't try to cut straight through it on the first attempt.

Always hold your ruler correctly to ensure neat lines: position the ruler along the line to be cut and hold the ruler in place with the fingers of your non-cutting hand, keeping them well away from the edge. Always make sure your ruler is lying on the part you intend to keep; this ensures that if the craft knife does slip, you will only cut through the outside areas that are being discarded.

Cutting curves will take a little practise for sure, so don't be disheartened. Just take it very slowly and carefully, and you will get there without too many mishaps.

SCORING AND INDENTING

There are two ways to prepare your card for an easier fold: scoring and indenting. Both techniques are valid, although indenting is a little easier to accomplish and holds less risk of damage to your card.

Scoring This technique lightly cuts through the surface of the paper or card. To score a fold line, place a metal ruler where you would like the fold to be. Next, carefully and gently slide the back of your craft blade along the edge of the ruler. As you want to scratch only the surface and avoid cutting all the way through, make sure you don't apply too much pressure. Your score lines should not be so deep that they break when the cardstock is folded, but deep enough to make a clean line that folds easily. Turn the card over and fold outwards so the scratched surface is on the outside.

Indenting This technique uses pressure to indent a line in the paper or card, making it easier to fold. It is used more often than scoring since there is no risk of cutting through the paper. To indent a fold line, place a metal ruler where you would like the fold to be, and use either a bone folder or the rounded end of a craft knife to press into the paper along the ruler edge. Fold the paper in on itself so that the indented crease is on the inside.

FOLDING

For each of the pop-up card projects, you will be required to make at least one fold, so the information that follows is very important. It is not as easy as you may think to achieve a smooth, flat fold. First, make sure to score or indent the fold line properly as described in Scoring and Indenting. Loosely fold along the crease and then slide your bone folder horizontally along the fold, beginning from the centre and moving outwards. Begin by pressing down lightly in case your fold takes a turn of its own and strays off the score line. Gradually add pressure to the bone folder until you have flattened the fold so it appears almost invisible.

USING TEMPLATES

The templates in this book are shown at 50 percent of the original size and need to be enlarged to 100 percent. To do this on a photocopier, enlarge the templates by 200 percent; alternatively, you can scan the templates on to your computer and print them out at 200 percent (please note, some projects will require a large-format printer). Many of the templates in this book can be printed directly on to your cardstock, or printed out and overlaid on your cardstock so that you cut through both sheets. There are a couple of other alternatives if you prefer to cut through a single layer of paper or card, or if you want to reuse your templates.

CARBON PAPER TRANSFER

Placing a piece of carbon paper between your card and your template allows you to transfer the design on to your card as you trace over the outline. This will leave a soft black line on your card, which you can then use as your cutting guide. It is important to mark on the fold lines too, but ensure they are distinctive in line type so that you do not cut them by accident.

TRACING PAPER TRANSFER

Trace the template on to tracing paper using a soft pencil. Turn the tracing paper over and transfer the marked design on to your card by drawing over them again with a harder pencil, such as an HB pencil. The pressure you apply should transfer the pencil marks from your original to your card. Make sure you transfer the fold lines carefully too.

TYPES OF FOLDS

When you look at your template, you will see that there are two main types of fold lines:

Valley Fold A dashed line indicates this type of fold. It is sometimes called a 'V' fold as it creates this shape when it is folded. With this fold, the crease is at the bottom (like a valley) and the card folds into itself.

Mountain Fold A dotted line indicates this type of fold. With this fold, the crease is at the top (like a mountain).

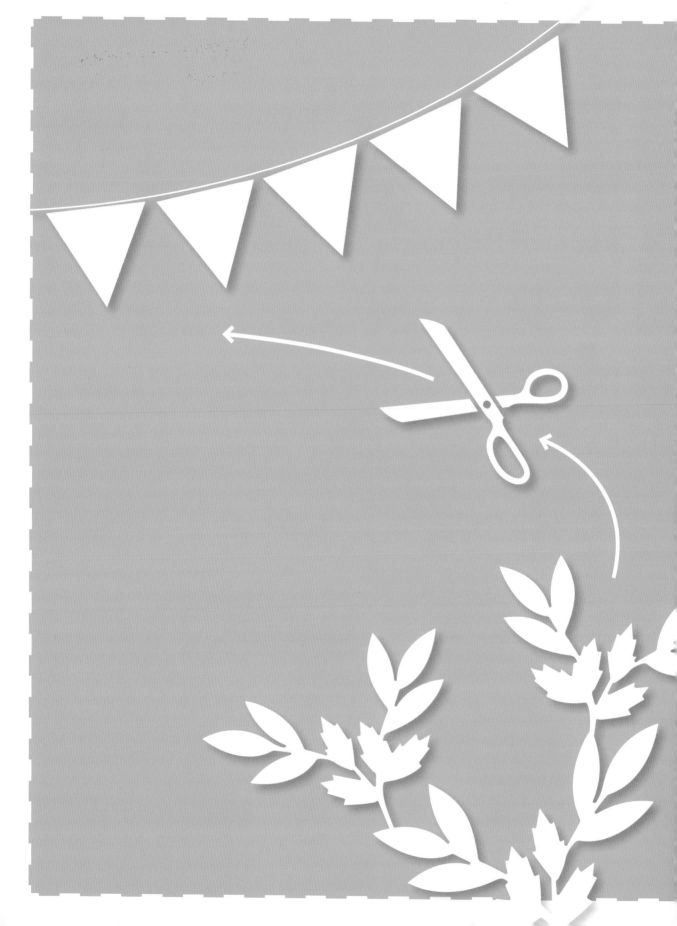

CHAPTER 1

CUTS & FOLDS

This is the perfect start to your pop-up card-making adventures. While these projects require some paper cutting patience, they are a great introduction to some simple pop-up techniques. Many are based on a simple folding mechanism, where the centreline fold serves as the 'hinge' from which shapes can pop out. Images can be cut and folded into a single piece of card, allowing the light to shine through, as you'll discover with the Medieval Castle (page 41) and the Wedding Birds (page 16) card designs. Alternatively, the paper cut can be attached to a base card, as with the Christmas Tree (page 43) and the Bird Box (page 24) cards.

Prepare to master your craft knife – the cutting and scoring tips on page 12 will help you to develop these skills. When it comes to cutting patterns with a steady hand, practice really does make perfect!

WEDDING BIRDS

Designed by: Lynn Hatzius

This delicate design of a pair of doves makes the ideal card for a wedding invitation. When the sides are folded in, the birds meet in the middle. To secure the card closed, you can tie a pretty ribbon around the birds' necks. The centre panel provides a generous space for the printed invite.

WHAT YOU NEED:

- Basic tool kit
- One piece of cream cardstock (160–180gsm) 130 x 290mm (5 x 11³/₈in)

1 Enlarge the template on page 115 to 100 percent using a photocopier. Lay the cardstock on a cutting mat. Centre the template on the cardstock and attach the edges with small strips of invisible tape.

2 Using a craft knife or scalpel, carefully cut along the solid black lines of the bird and heart designs through the template and the cardstock beneath. Use the tip of the craft knife to pierce the top and bottom dots that mark the fold lines. Finally, use a metal ruler to cut along the outer straight edges. Remove the template.

3 Carefully remove the cut pieces of card from the design, releasing any uncut details from the birds' wings and tails with your craft knife. Now score the fold lines: place a metal ruler to connect the marked dots and run the blunt edge of the craft knife between them (do not score through the birds' bodies).

4 Gently fold the wing and tail parts of each bird backwards along the outer scored lines (mountain fold). Then lift each bird forward one by one towards the centre of the card to fold along the inner scored lines (valley fold).

5 Press each bird all the way down to lay flat and run your finger along the folds. The birds' heads will overlap, and to hold the card shut, the beaks can be tucked beneath the opposite bird's wing. To open and display, pull the outer edges of the card apart.

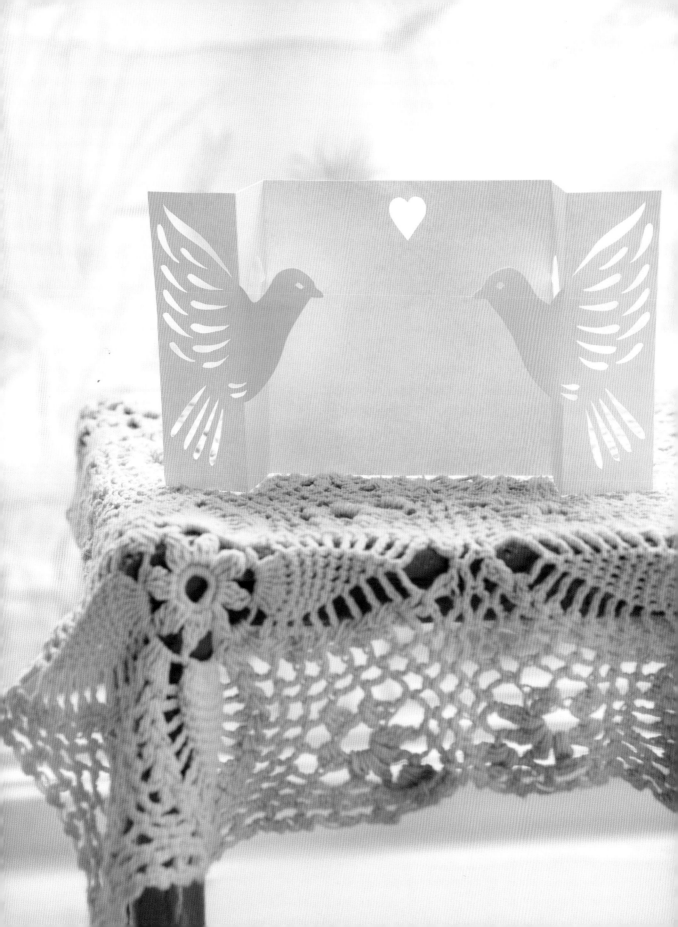

POT OF FLOWERS

Designed by: Freya Lines

This bright pot of flowers makes a lovely Mother's Day gift or a perfect birthday card for a budding gardener. A simple but effective design, it is a great decoration for the windowsill long after the event. Get creative and try changing the colours, or adapt the paper cut design to create a different pot plant.

WHAT YOU NEED:

- Basic tool kit
- Two pieces of cardstock (160–180gsm) 148 x 210mm (5⁷⁄₈ x 8¹⁄₄in): one white, one orange

1 Fold the white cardstock in half, open it again, and attach it to a cutting mat using small strips of invisible tape.

2 Enlarge the template on page 115 to 100 percent using a photocopier. Lay the template on top of the white cardstock and line up the edges neatly before taping it in place. (Note: this design will appear reversed on the final card.)

3 Using a scalpel and a metal ruler for the straight edges, carefully cut along the solid black lines through the template and the cardstock beneath. Be careful not to cut the areas of the pot that keep it connected to the card. Remove the template. Carefully remove the cut pieces of card from the design, releasing any uncut details with your scalpel. Turn the paper cut over to the right side, as shown in the photo.

4 Now fold the paper cut panel in half once again, making sure the pot folds inwards to form a mountain fold.

5 Fold the orange cardstock in half to make the base card. Glue the pot of flowers paper cut design inside the folded orange card. Stick the right-hand panel in place first: align the edges neatly and be very careful not to glue the flowerpot or flowers to the background; then stick the left-hand panel in place.

6 Once the glue has dried completely, fold the base card closed, and if any white card can be seen, trim it away at the edges for a neat finish.

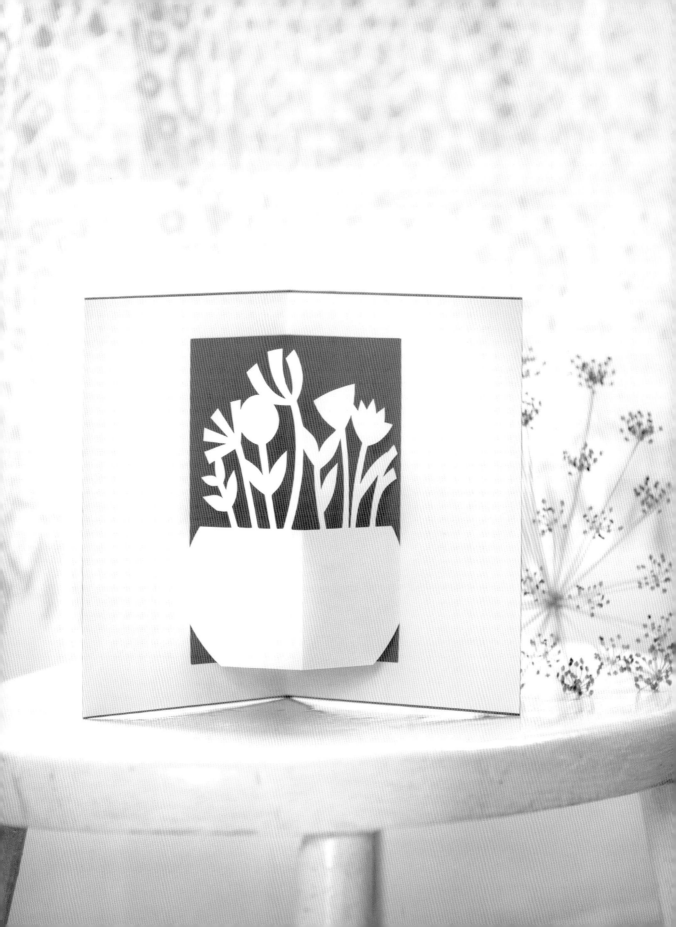

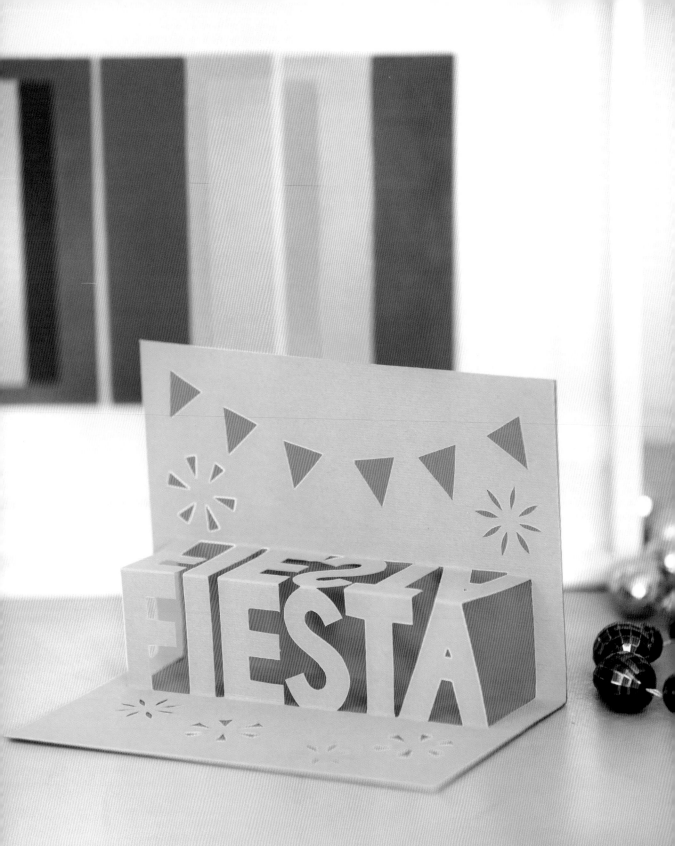

FIESTA

Designed by: Freya Lines

This simple Mexican-inspired paper cut uses just three folds to make it pop. The 'fiesta' design is the perfect party invitation, and the details of the event can be written or printed on the back of the card. You can create your own word or name to personalise it for a special occasion – just make sure your letters remain attached at the folds.

WHAT YOU NEED:

- Basic tool kit
- Two pieces of cardstock (160gsm) 148 x 210mm (5⁷/₈ x 8¹/₄in): one blue, one orange

1 Enlarge the template on page 116 to 100 percent using a photocopier. Fold the blue cardstock in half, and then open it again. Use small strips of invisible tape to attach the cardstock to a cutting mat. Lay the template on top of the card and line up the edges neatly before taping it in place.

2 Using a craft knife and a metal ruler for the straight edges, cut along the solid black lines through the template and the cardstock beneath. When you have finished cutting the design, remove the template and peel off the tape to release the cardstock from the mat. Carefully remove the cut pieces of card from the design, releasing any uncut details with your craft knife.

3 Score the fold lines at the top and bottom of the letters by running the blunt edge of the craft knife along the straight edge of a metal ruler. Fold the card in half, and then crease the baseline of the letters over the edge of the metal ruler, as shown in the photo.

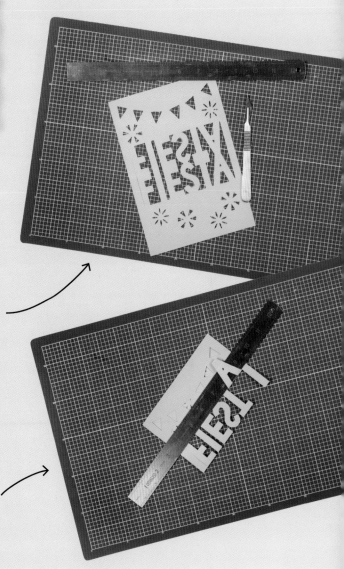

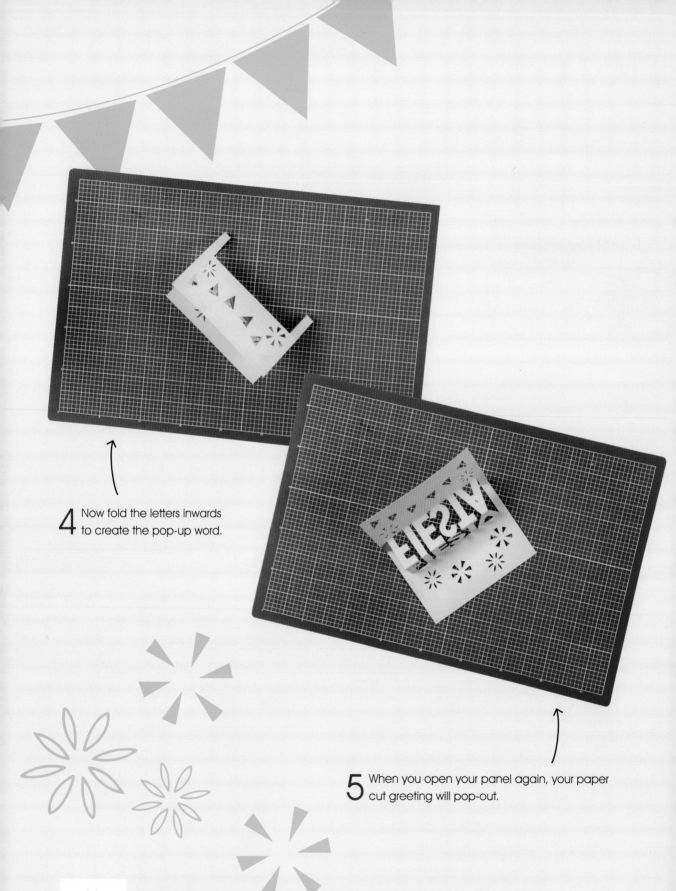

4 Now fold the letters inwards
to create the pop-up word.

5 When you open your panel again, your paper
cut greeting will pop-out.

6 Fold the orange cardstock in half and then open it again. This is your base card. Glue the fiesta paper cut to the inside of the orange base card, but be very careful not to apply glue to the letters – otherwise the word will not pop up when the card is opened.

7 Once the glue has dried completely, fold the base card closed, and if any blue card can be seen, trim it away at the edges for a neat finish.

BIRD BOX

Designed by: Whispering Paper

Pull down the front panel of this card to reveal the box frame pop-up – a beautiful bird in a tree that comes to life before your eyes. This delightful card can be re-imagined by simply substituting the design to suit the occasion. A forest scene, a cityscape, a birthday cake, or any abstract pattern would all work well for this style of pop-up.

WHAT YOU NEED:

- Basic tool kit
- One piece of yellow cardstock (160–180gsm) 148 x 210mm (5⁷/₈ x 8¹/₄in)
- One piece of taupe paper (160gsm) 148 x 210mm (5⁷/₈ x 8¹/₄in)

1 Fold the yellow cardstock in half so that the fold is at the bottom edge. This is your base card.

2 Enlarge the template on page 116 to 100 percent using a photocopier and transfer it to the taupe paper using tracing paper or carbon paper. (Note: this design will appear reversed on the final card.)

3 Working on a craft mat and using a craft knife, carefully cut along the solid black lines of the bird in a tree design, removing the cut pieces as you go. Begin by cutting the smallest pieces first to preserve the paper's strength for as long as possible. Use a metal ruler when cutting the straight lines.

4 Using a metal ruler and the sharp end of a bone folder, score along the fold lines. To make the bird pop-up, fold the dashed line back to create a valley fold; then fold the dotted lines forward to create mountain folds. (Note: these folds will appear the opposite way around on the final card as the paper cut panel is turned.) Press the paper firmly shut to enhance the folds.

5 Open the paper cut design and apply glue to the bottom (uncut) panel. Open the base card and turn the paper cut to stick the glued panel on to the lower half of the yellow base card, carefully aligning the edges.

6 Press the paper cut design shut (but not the yellow cardstock) and apply glue all around the uncut border. Be very careful not to get any glue on the paper cut panel or it will not pop out properly. Shut the cardstock over the pop-up; open it again carefully before the glue dries to check that all the edges align and that the box frame pops up.

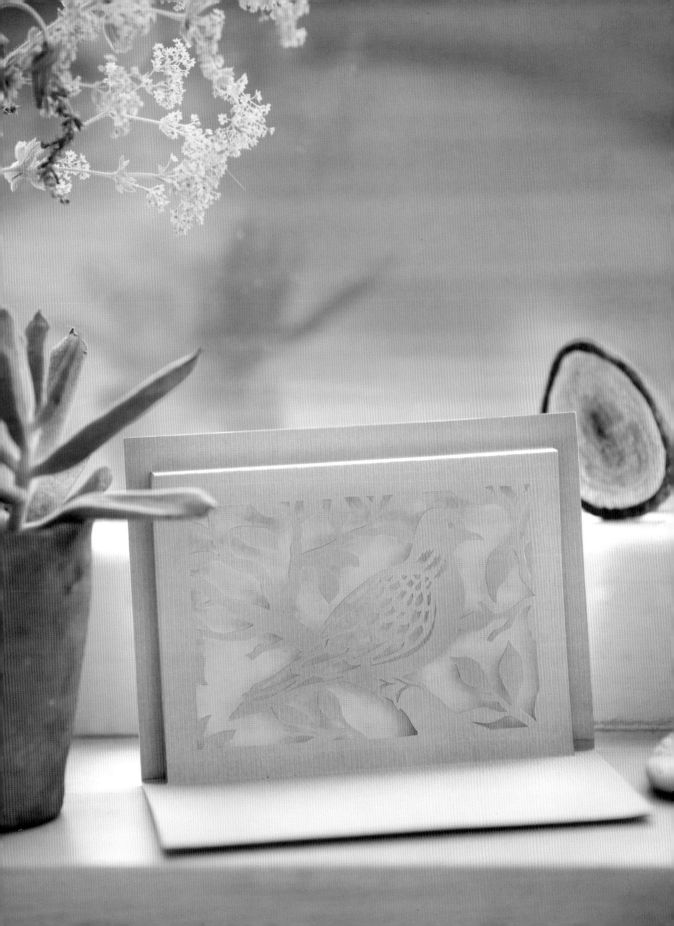

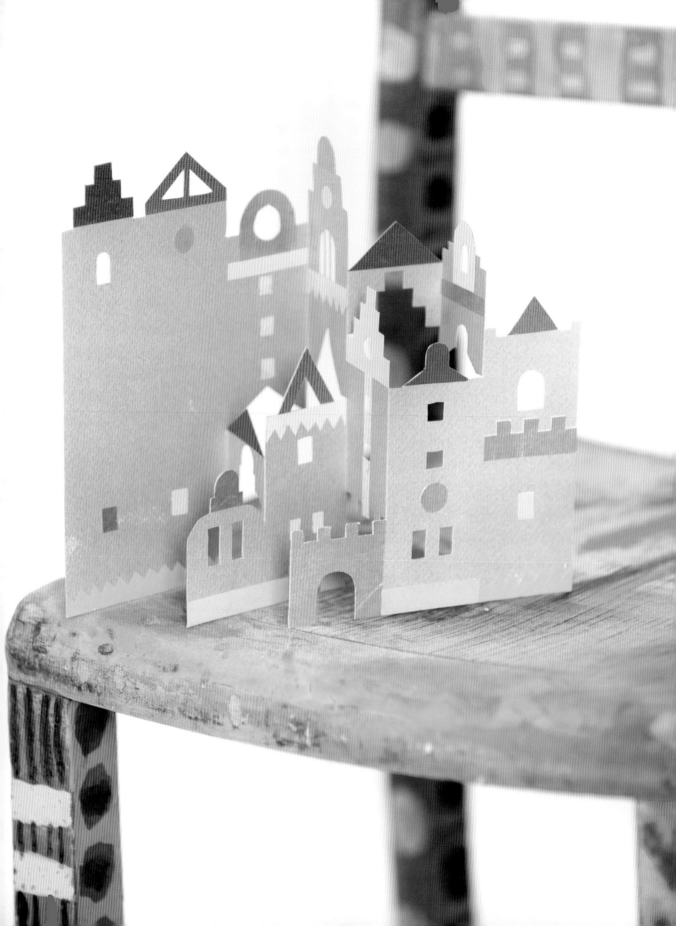

KNIGHT'S FORTRESS

Designed by: Lynn Hatzius

This magical card makes use of the classic concertina fold to ensure the castle stands on firm foundations. The sculptural design makes a great shelf decoration for a child's bedroom. Use bold, bright colours for a knight's fortress as shown, or choose pretty pastel shades for a princess's palace.

WHAT YOU NEED:

- Basic tool kit
- One piece of blue cardstock (160–180gsm) 260 x 160mm (10$\frac{1}{8}$ x 6$\frac{1}{4}$in)
- Paper (70–90gsm) in a variety of colours, each approximately 50 x 100mm (2 x 4in)

1 Enlarge the template on page 117 to 100 percent using a photocopier, and use scissors to roughly cut around the outer edge of the castle. Lay the blue cardstock on a cutting mat. Centre the template on the cardstock and attach the edges with small strips of invisible tape.

2 Using a craft knife and a metal ruler for the straight edges, carefully cut along the solid black lines *inside* the castle design to open up the windows and release the lower roof silhouettes. Use the tip of the craft knife to pierce the dots that mark the fold lines. Finally, cut around the outline, and then remove the template.

3 To score the fold lines, place the metal ruler along the lines of pierced dots and run the blunt edge of the craft knife along them, taking care to fold valley or mountain folds as marked.

4 Gently push the cardstock apart along the internal cut lines to ensure all elements separate. To create the pop-up, fold the card along the scored lines by lifting the mountain folds forward – the valley folds will form automatically as you close the card. Press firmly to enhance folds.

5 To decorate the castle, cut small detail sections from coloured paper and glue them to the front of the card using a glue stick.

FOX ON THE HILLSIDE

Designed by: Lynn Hatzius

This stunning silhouette scene is made using just a few basic folds. You could make a series experimenting with different coloured cardstock. For a fox at sunset, for example, try black for the paper cut and yellow for the background. But do be careful when separating the cut-out pop-up elements from the foreground card, as they are a little delicate.

WHAT YOU NEED:

- Basic tool kit
- One piece of cream cardstock (160gsm) 160 x 220mm (6^1/$_4$ x 8^5/$_8$in)
- One piece of navy blue cardstock (160–180gsm) 148 x 210mm (5^7/$_8$ x 8^1/$_4$in)

2 Use a craft knife to carefully cut along the solid black lines of the hills within the design, cutting through the template and the cardstock beneath. Use the tip of the craft knife to pierce the dots that mark the fold lines. Using a pair of scissors, cut along the edge of the template, starting with the mountain ridge at the top of the design.

3 Remove the template. Gently push the cardstock apart along the cut lines to ensure all elements separate from the background. Now score the fold lines: place a metal ruler to connect the marked dots and run the blunt edge of the craft knife between them.

4 To create your pop-up, start by folding the cream cardstock along the scored lines marked M for mountain folds, gently pushing them forwards with your fingers from the back of the card. Then close the card gently to create the valley (V) folds. Press the card firmly shut to enhance all the folds, and then open it again.

5 Turn the pop-up panel to the reverse, and cover the side edges and the top mountain ridge with a thin, even layer of glue. Fold the navy blue cardstock in half so that the fold is at the left-hand edge. This is your base card. Slide the pop-up panel inside until the centrelines touch, and then press together. Open to check that the outer edges and bottom corners of both cards line up, and adjust if necessary before the glue dries.

1 Enlarge the template on page 117 to 100 percent using a photocopier, and cut it out along the outer edges. Lay the cream cardstock on a cutting mat. Centre the template on the cardstock and attach the edges with small strips of invisible tape.

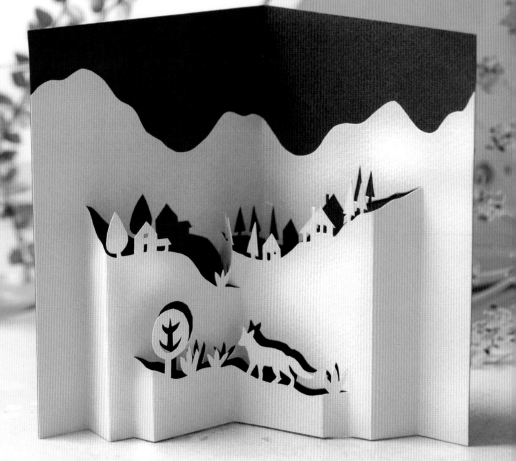

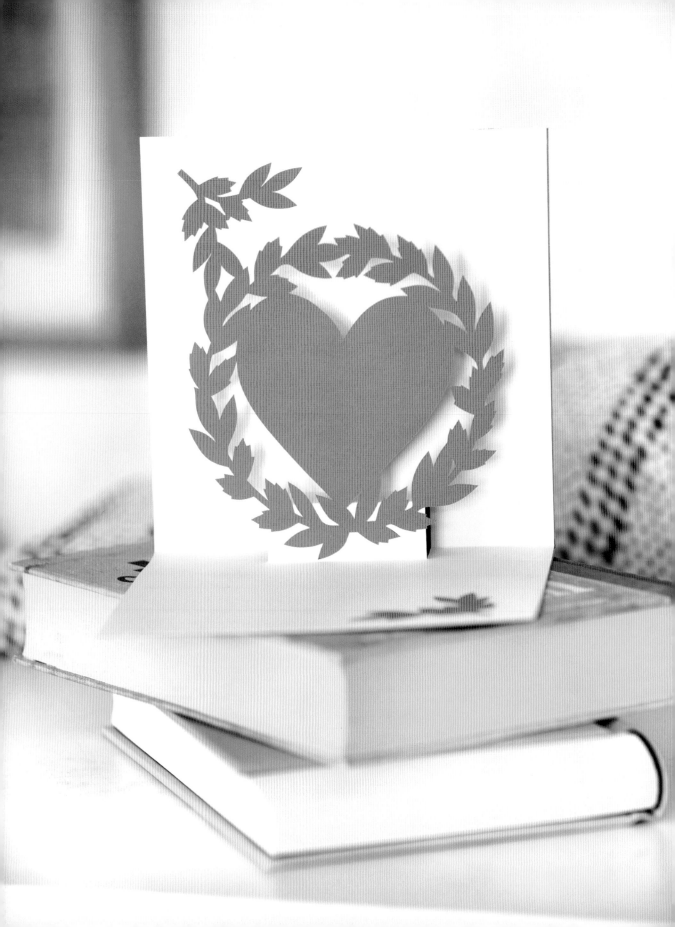

WREATH HEART

Designed by: Freya Lines

This pop-up is based on a simple mechanism – a pop out 'hinge' is cut into the centreline to which the paper cut is attached. The wreath heart design is ideal for an engagement or wedding anniversary, and once you have mastered the technique, you can create your own decoration to suit the occasion.

WHAT YOU NEED:

- Basic tool kit
- Two pieces of cardstock (160–180gsm) 150 x 300mm (6 x 12in): one pink, one mint green
- One piece of pink cardstock (160–180gsm) 148 x 210mm (5^7/$_8$ x 8^1/$_4$in)

1 Using the pink and mint green cardstock pieces measuring 150 x 300mm (6 x 12in), lightly score a line down the centre of each. Then fold each piece in half to create two 150mm (6in) square base cards.

2 Now mark the pop-up tab on to the mint green base card. With the folded edge of the card on the right-hand side, use a ruler and pencil to measure and lightly mark a line 2cm (³/₄in) in from the folded edge, and then measure 4cm (1¹/₂in) from the top and bottom edges of the card and lightly draw lines to the first marked line.

3 Lay your card on a cutting mat, and use a metal ruler and craft knife to cut the horizontal marked lines only towards the folded edge. Fold the cut centre tab backwards over the metal ruler and press down firmly with your fingers.

4 Open the card and fold the tab inwards to create the pop-up hinge.

5 Next, cut the paper cut wreath heart and the leaf decorations. Enlarge the template on page 117 to 100 percent using a photocopier. Lay the remaining piece of pink cardstock on a cutting mat, position the template on the cardstock and attach the edges with small strips of invisible tape. Using a craft knife, carefully cut along the solid black lines through the template and the cardstock beneath. Carefully remove the template.

6 First glue the leaf decorations on to the corners of the mint green pop-up base card. Then apply glue to the front edge of the tab only and stick the wreath heart paper cut on to the tab.

7 Now open your pink base card. Close the mint green pop-up card and apply a thin layer of glue to the back of the card. Stick the pop-up panel to the pink base card, lining them up at the fold lines in the centre.

8 Once the glue has dried completely, fold the pink base card closed, and if any mint green card can be seen, trim it away at the edges for a neat finish.

BIKE RIDE

Designed by: Freya Lines

In this sweet countryside scene, a delicate paper cut bicycle rises up from a simple double-hinge pop-up against a backdrop of beautiful foliage. For even more texture, tufts of grass are cut into the foreground of the three-dimensional design. This card would make a delightful invitation to a picnic on wheels.

WHAT YOU NEED:

- Basic tool kit
- One piece of mustard yellow cardstock (160–180gsm) 148 x 210mm (5$^7/_8$ x 8$^1/_4$in)
- One piece of mint blue cardstock (160–180gsm) 105 x 148mm (4$^1/_8$ x 5$^7/_8$in)
- One piece of yellow cardstock (160–180gsm) 105 x 148mm (4$^1/_8$ x 5$^7/_8$in)

1 Fold the mustard yellow cardstock in half, and use a pencil and ruler to lightly mark the pop-up tabs along the folded edge. To do this, mark a line 2cm ($^3/_4$in) in from the folded edge. Measure 2cm ($^3/_4$in) down from the top edge of the card and draw a line to the first marked line; measure 4cm (1$^1/_2$in) down from this line and draw another line to mark the first tab. Repeat to mark a second tab 2cm ($^3/_4$in) from the bottom edge of the card.

2 Lay your card on a cutting mat. Use a metal ruler and craft knife to cut the horizontal marked lines only towards the folded edge. Fold the cut tabs backwards over the metal ruler and press down firmly. Open the card and fold the tabs inwards to create the pop-up hinges.

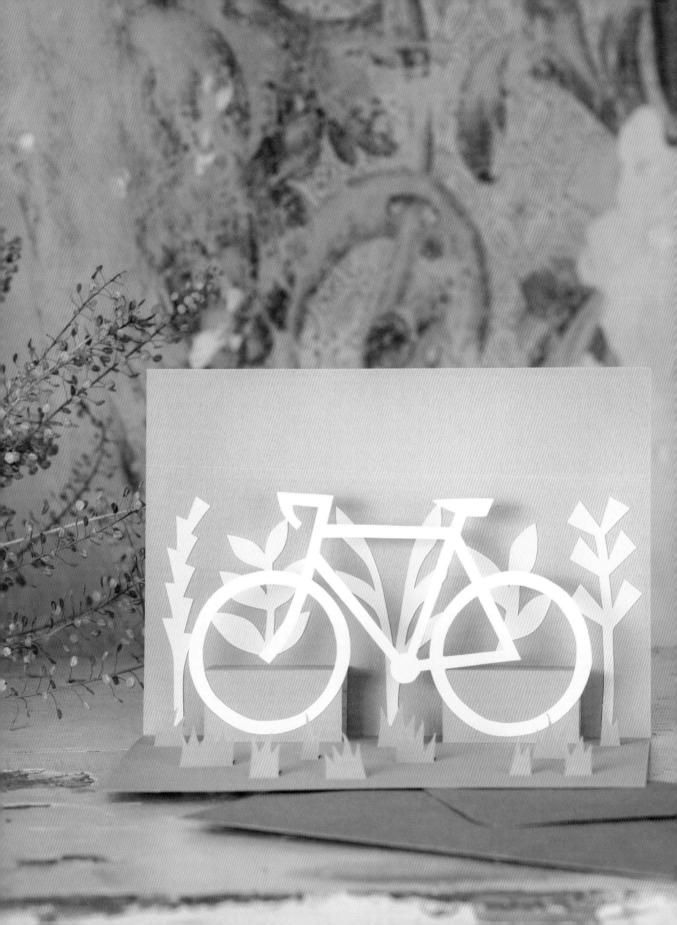

3 Next, cut the paper cut decorations. Enlarge the bike and foliage templates on page 118 to 100 percent using a photocopier. Lay the mint blue and yellow cardstock pieces on to a cutting mat, lay the relevant template on top, and attach the edges with small strips of invisible tape. Using a craft knife, carefully cut along the solid black lines through the templates and the cardstock beneath. Remove the templates.

4 Glue the foliage in place to make the background on the base card, positioning them to sit just above the centreline.

5 Enlarge the grass tufts template on page 118 to 100 percent using a photocopier, and transfer the shapes so they are scattered across the foreground, repeating some. Lay the card on your craft mat and cut along the marked grass tufts; make sure the tufts are released from the card, but leave them flat.

6 Apply a thin line of glue to the lower part of the bicycle wheels, and carefully stick them on to the tabs.

7 Once the glue has dried, you can fold the card neatly closed. Add a note on the back of the card to advise that the grass tufts need folding up.

BEE & HONEYCOMB

Designed by: Lynn Hatzius

Even before it is opened, the unusual shape of this card makes it stand out as something special. At the centre of the honeycomb background is a pop-up bee, a creature that symbolises family, community and productivity. This card is ideal for a wide range of occasions, from birth congratulations to graduations.

WHAT YOU NEED:

- Basic tool kit
- One piece of dark brown cardstock (160–180gsm) 220 x 150mm (8⅝ x 6in)
- One piece of tracing paper (70–90gsm) 130 x 40mm (5 x 1½in)
- Two pieces of paper (70–90gsm) 150 x 100mm (6 x 4in): one yellow, one gold

2 Lay the brown cardstock on a cutting mat and use a craft knife to carefully cut along the solid black lines *inside* the honeycomb shape. Use the tip of the craft knife to pierce the dots that mark the fold lines. Finally, use a pair of scissors to cut around the outer line of the honeycomb. Remove the template. Carefully remove the cut hexagons from the design and make sure the outline of the bee is released from the background card.

3 Use one of the hexagons cut from the background card in step 2 as a template to lightly mark out 10–12 hexagons on both the yellow and gold papers. Use scissors to cut out the hexagon shapes.

1 Enlarge the template on page 118 to 100 percent using a photocopier, and roughly cut out around the outer edges of the three parts of the template: the honeycomb, the wings and the bee's stripes. Attach the honeycomb template to the brown cardstock, the wings to the tracing paper and the bee's stripes to the yellow paper, using small strips of invisible tape. Set aside the prepared bee's stripes and the wings.

7 Now score the vertical fold lines of the centre and wing folds: connect the marked dots with a metal ruler and run the blunt edge of the craft knife between them. To create the pop-up, lift the bee up, holding it by the fold line in the centre, and squeeze the body together – this will make the legs fold up and the card close. Use the knife tip to push back the section for the wings, and again squeeze the body flat to enhance all the folds.

4 Glue the hexagons across the honeycomb base card, making sure they align with the outer edges and the cut-out hexagon shapes. For instructions on sticking the hexagons beneath the bee, see steps 5 and 6.

5 For the hexagons that are overlapped by the bee's upper and lower legs, apply glue to the edges of the paper hexagons only and stick them in place over the legs. Turn the card to the reverse and cut through the bee's legs from the back of the card to release the paper beneath. Turn the card right side up, cut off the loose bits of paper that cover the legs, and glue down the rest of the hexagon around the shape of the bee.

6 For the hexagons below the head and tail, slide the paper hexagons under the bee shape and stick them down. Then turn over the card and release the overlap of paper by cutting around the bee shape with your craft knife.

8 Take the prepared wings from step 1 and use scissors to carefully cut out the wings. Remove the template and fold the wings in half to create a centreline. Apply some glue along each side of the folded edge, and then slot the tracing paper wings over the wing section of the bee's body, so it lines up with the centreline of the pop-up section created in step 7. Press the card firmly shut and hold it in place until the glue has dried.

9 Lay the prepared bee's stripes from step 1 on to your cutting mat and use a scalpel to carefully cut along the solid black lines through the template and the cardstock beneath. Remove the template and release the cut bee's stripes from the background card. Apply glue to the back of each stripe and stick them in place on the bee's body.

10 Once the glue has dried, close the card and decorate the front of the closed card with any leftover yellow or gold hexagons.

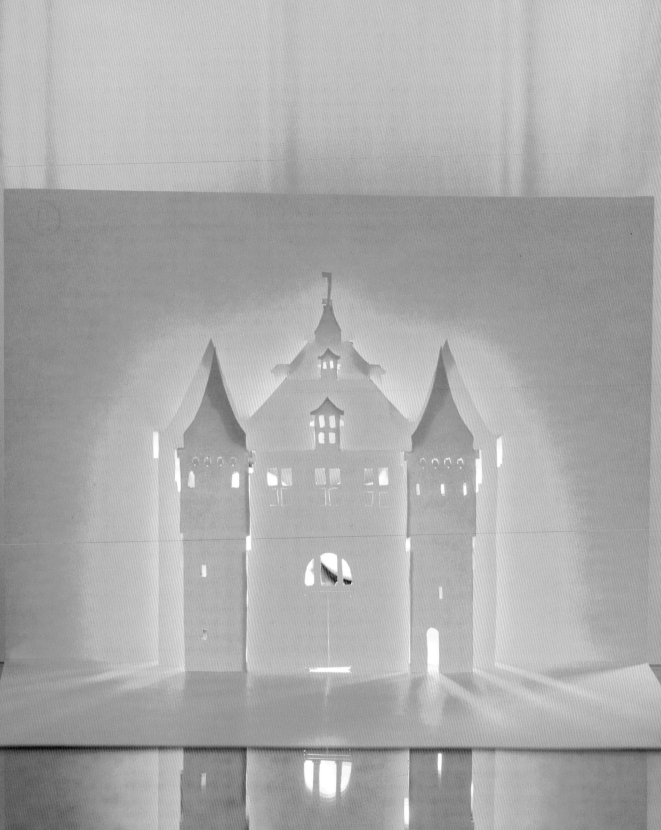

MEDIEVAL CASTLE

Designed by: Ingrid Siliakus

The intricate detail of this pop-up medieval castle design is based on a real building, the De Waag (or weigh house) in Amsterdam, the Netherlands. This challenging paper cut cannot be rushed, but you will be rewarded for the time invested in completing it when backlighting reveals the spectacular result.

WHAT YOU NEED:

- Basic tool kit
- One piece of cream cardstock (160–250gsm) 210 x 297mm (8¼ x 11¾in)

1 First, mark the centreline on the cream cardstock to give you a guideline for template placement: use a ruler to find the mid point of the long edges and draw a faint pencil line along each edge on the front of the cardstock.

2 Enlarge the template on page 119 to 100 percent using a photocopier. Lay the cardstock on a cutting mat. Place the template on the cardstock, lining up the centrelines, and attach the edges with small strips of invisible tape.

3 Using a scalpel and a metal ruler for the straight lines, carefully cut along the solid black lines through the template and the cardstock beneath. Start by cutting the details, such as the windows and doors, and carefully lift your template often to ensure you are cutting through.

4 Next mark the fold lines, starting first with the valley folds (blue dashed lines). Use the tip of the scalpel to pierce a tiny hole at the beginning and end of each line.

5 Once you have marked all the dashed lines, carefully remove the template, and turn the cardstock over to lightly score the valley folds on the back of the cardstock. Place a metal ruler between the two holes that mark each valley fold line (use your template as a guide) and run the blunt edge of the craft knife between them.

6 Turn the cardstock over to the front and reposition as before to mark the mountain folds (red dotted lines). Then remove the template and score the mountain fold lines on the front of the cardstock. Erase the centreline pencil marking on the cardstock.

7 As you fold the pop-up into shape, it is important to take your time. Start by folding along the centreline and see which folds appear by themselves. Keep one hand on the back of the card and one at the front, and try to make the folds as carefully as possible. Do not push the folds all the way at once; instead, gently bend them little by little. Keep returning to the centreline each time you bend the folds a little further into shape; remember, some of the folds will be more difficult to reach as the card slowly finds its form. If lines resist folding, make them a little deeper by scoring or cutting a bit more, but be very careful.

8 When all parts of the card have been folded far enough, carefully close the card and press it firmly shut. Open it again and the castle will rise.

CHRISTMAS TREE

Designed by: Rosa Yoo

Christmas is everyone's favourite time for sending cards. Make yours a standout card this year by creating this beautiful pop-up Christmas tree design. Be sure to make an extra one for yourself, as this design doubles up as a gorgeous decoration for the middle of your festive mantel.

WHAT YOU NEED:

- Basic tool kit
- Three pieces of cardstock (160–180gsm) 210 x 297mm (8¹/₄ x 11³/₄in): one green, one red, one white
- One small square of yellow cardstock (160gsm)

1 Enlarge the Christmas tree card templates on page 120 to 100 percent using a photocopier. There are four templates in all – Christmas tree, base, cover and star.

2 Lay the green cardstock on a cutting mat. Centre the tree template on the cardstock and attach the edges with small strips of invisible tape. Before cutting the template, you must first indent all the dashed and dotted lines to mark the folds – this is very important.

3 Once you have finished indenting the fold lines, you can carefully cut along the solid black lines through the template and the cardstock beneath, using a craft knife and a metal ruler. Start by cutting along the outer edges of the template, and then cut the solid lines of the presents and the tree, but *do not* cut through the horizontal dashed and dotted fold lines. Remove the template.

4 Fold the indented fold lines, noting whether they are valley (blue dashed lines) or mountain (red dotted lines) folds. Use your fingers to gradually push the mountain folds from the back of the card to the front.

5 Lay the white cardstock on a cutting mat. Centre the base template on the cardstock and attach the edges with small strips of invisible tape. Using a craft knife and a metal ruler, carefully cut along the solid black lines through the template and the cardstock beneath, cutting along the outer edges first. Then cut out the tree and presents. Score along the centreline with the blunt edge of the craft knife. Remove the template and fold the card in half.

6 Use the cover template to cut the cover from the red cardstock, remembering to cut the semi-circular slits at each corner. Also remember to score along the centreline with the blunt edge of the craft knife. Remove the template and fold the card in half.

7 Place the base (white) card on top of the tree (green) card. Gently ease out the raised tree to sit in front of the base piece. Make sure the pieces lie smoothly on top of each other and that the cut-out present shapes are aligned.

8 Take the layered base/tree piece and slot it into the slits in the corners of the cover (red) card, and fold the card shut carefully. Open up the card once more. Use the star template to cut a star from the yellow cardstock and glue it to the tab at the top of the tree to finish.

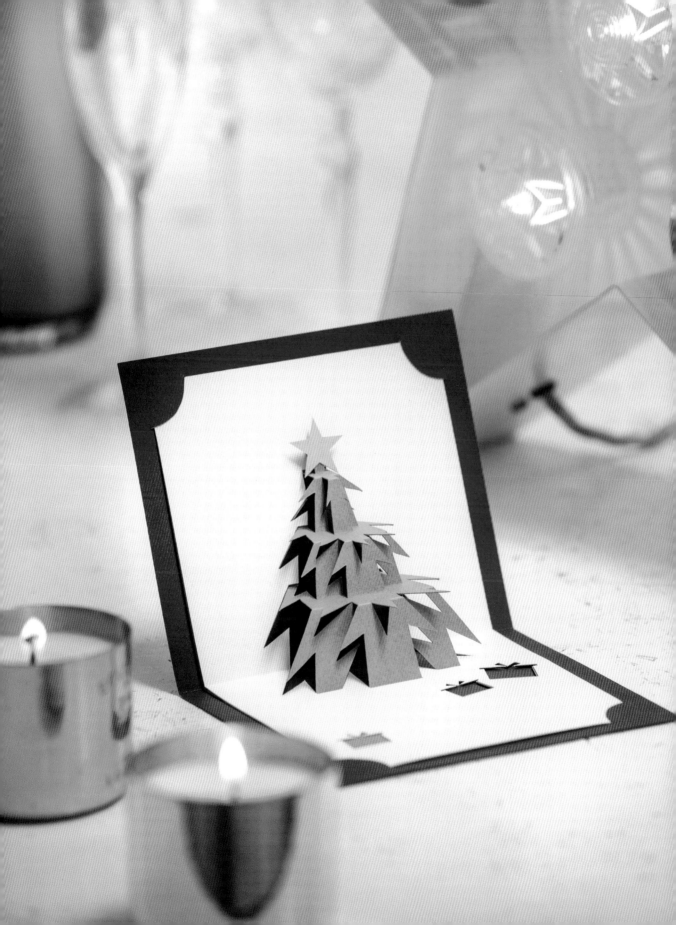

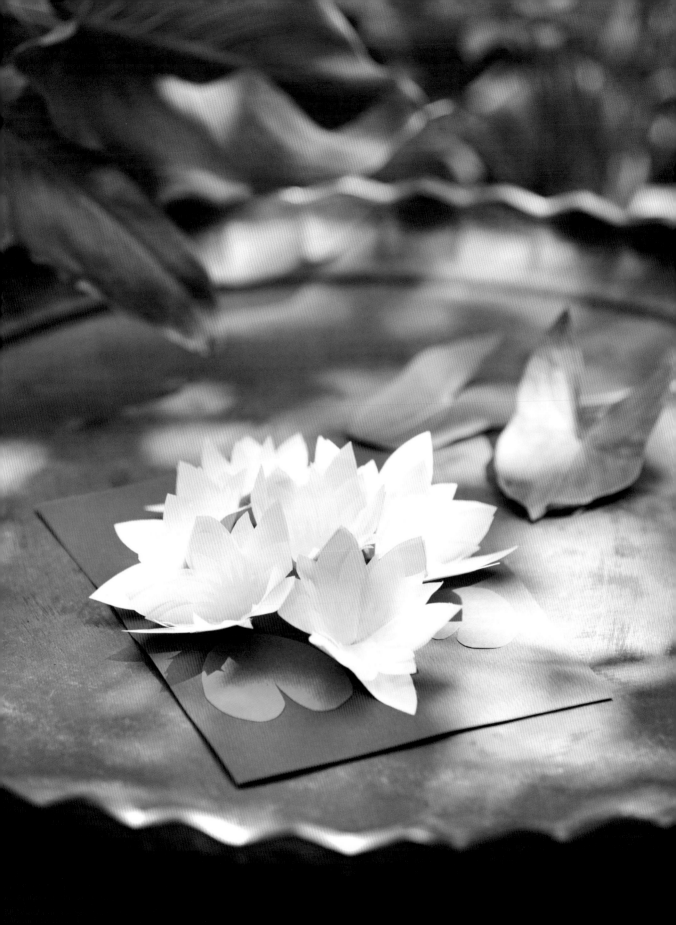

WATER LILIES

Designed by: Whispering Paper

Water lilies bloom before the eyes as this card is opened. Tissue paper is used to make some of the petals, capturing the delicate texture of the flower. If you want to achieve an even more realistic effect, you can add a little pink watercolour to the inside of each petal, fading outwards.

WHAT YOU NEED:

- Basic tool kit
- Two pieces of white paper (80gsm) 210 x 297mm (8^1/$_4$ x 11^3/$_4$in)
- Tissue paper: yellow and white
- One piece of mid-blue cardstock (160–180gsm) 148 x 210mm (5^7/$_8$ x 8^1/$_4$in)
- Small piece of green paper (80gsm)

1 Enlarge the water lily petal templates on page 119 to 100 percent using a photocopier, and cut out each petal template. Use the largest petal template to cut seven petals from white paper and use the smallest petal template to cut seven petals from yellow tissue paper. Using the other two petal templates, cut seven petals each from white tissue paper. (See step 2 for cutting instructions.)

2 Follow this step for the quickest way to cut out the petals. Cut seven squares of the relevant paper (see step 1) and stack them on top of each other, taping the petal template on top. (In the photo below, the smallest petal is ready to be cut from the yellow tissue paper.) Tape the edges of the paper stack together to keep the layers in place as you cut around the petal template with a small pair of scissors, cutting all seven petals at once.

3 To make a water lily flower, glue a set of four petals on top of each other in order of descending size, starting with the largest petal and finishing with the smallest. Apply glue to the centre of the petals, keeping the petal tips glue-free, and stack the petals precisely on top of each other, aligning the edges at the base of each petal to keep the opening.

4 Run a line of glue from the centre of the petal to the left-hand side of the opening. Fold the petal on the right-hand side of the opening on top of the glued petal to make a cupped flower. Repeat steps 3 and 4 to make seven flowers in all.

5 Fold each flower in half, making sure to fold the flower flat between the petals so that the glued petal lies in the middle. You are now ready to begin joining the flowers together, following the instructions in steps 6–9.

6 Lay flower 1 on your work surface with the petals at the top. Apply a small dot of glue to each of the tips of the outer petals. Place flower 2 on to the left-hand petal and flower 3 on to the right-hand petal, and align the edges.

7 Apply a small dot of glue to the right-hand petal of flower 2, to the left-hand petal of flower 3 and to the centre petal of flower 1. Then place flower 4 on top of flowers 1, 2 and 3, taking care to align the edges.

8 Apply a small dot of glue to each of the three petals on the left-hand side of the flower stack as well as the three petals on the right-hand side of the flower stack. Leave the top petal free of glue. Place flowers 5 and 6 to the left- and right-hand sides of the flower stack.

9 Apply a small dot of glue to the top centre petal and to the petals on either side of it, and finally place flower 7 on top to complete your flower stack.

10 Fold the mid-blue cardstock in half to make the base card and open it again. Lay the flower stack in the centreline of the base card as shown, and apply a small dot of glue to the tip of the centre petal on the right-hand side.

11 Close the base card and press firmly. Open the card again and apply a small dot of glue to the tip of the centre petal on the opposite side of the flower stack. Close the card and press firmly once again.

12 To add a couple of leaves, draw the water lily leaf shapes on to the green paper – start with an egg shape and make an indentation on the widest side. Use scissors to cut out the leaves and then stick them in place as you wish.

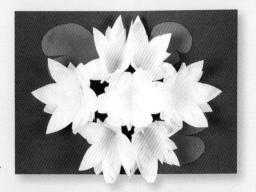

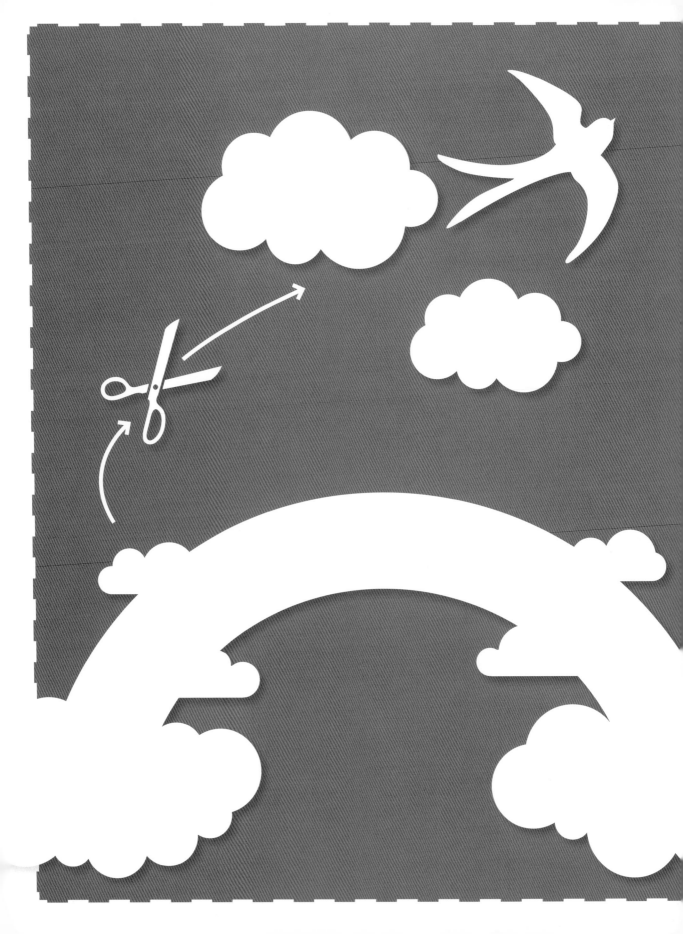

CHAPTER 2

TABS, SLOTS & LAYERS

When you use tabs, slots and layers, you'll find your pop-up cards have even more impact. Many of the projects in this chapter have been designed to fold out flat and rest open, becoming keepsake shelf decorations that last long beyond the event they were made to celebrate – for example, the tabbed Carousel (page 55) and the floating, layered Snail on a Leaf (page 61). Others, such as the Ocean Tunnel (page 59) and the Penguin (page 52) cards, have been created as stand-alone paper sculptures.

You will also discover how to use tabs and slots to make your cards interactive for extra fun. On the Flying Swallow card (page 81), for example, a string pulley system sends a bird flying through the clouds. On Cupcake Kitty (page 71), a cherry pull-tab reveals a cheeky kitten. Get creative, and use these skills and techniques to make any scene you can imagine.

PENGUIN

Designed by: Mary Beth Cryan

This penguin card pops to life when it is taken from the envelope to stand upright on its folded tail and feet, revealing a back pocket that is perfect for storing pens and pencils. The design includes a message panel for the back pocket – a space for you to write a birthday greeting to an animal-loving friend.

WHAT YOU NEED:

- Basic tool kit
- Black or blue cardstock (280gsm): two pieces 150 x 200mm (6 x 8in) and one piece 75 x 130mm (3 x 5in)
- Small pieces of orange and white cardstock (220gsm)
- Coloured pens or pencils

1 Enlarge the templates on page 121 to 100 percent using a photocopier. Use scissors to cut out the templates following the black outlines.

2 Take the body front and back templates, tape them to black or blue cardstock, and cut them out. Score the dashed lines using a bone folder and metal ruler, and then remove the templates.

3 Lay the body pieces side by side ready to join them together, and glue the tab on one piece to the back of the other.

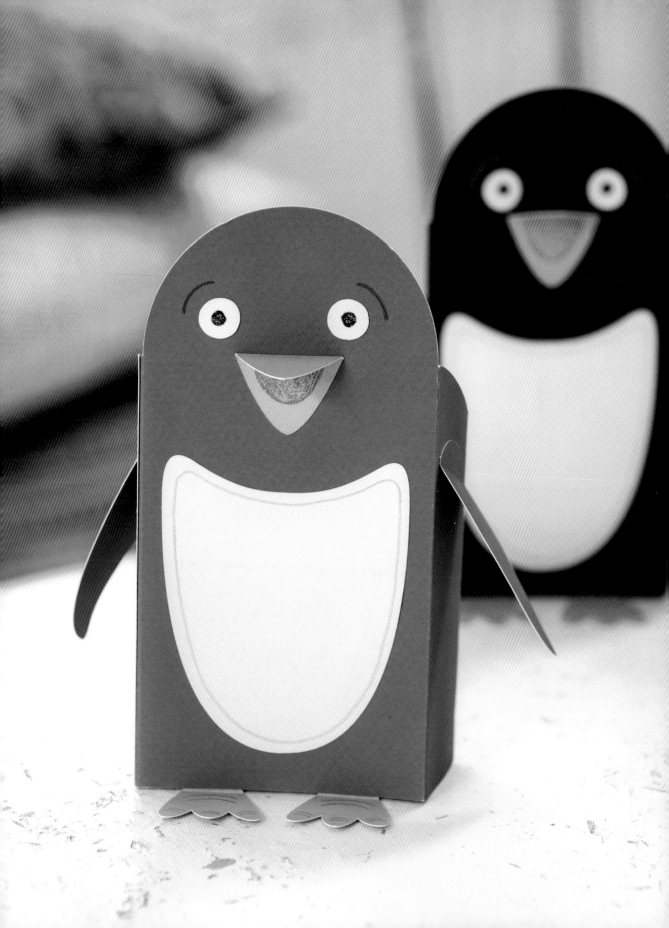

4 Close the body by gluing the last tab in place, and then fold up the tail at the base to support it in a standing position. The penguin's body is now ready to be decorated.

5 Using small strips of invisible tape, attach the eyes, message panel and chest templates to the white cardstock; the wing templates to the black or blue cardstock; and the feet and beak templates to the orange cardstock.

6 Turn your prepared pieces of cardstock over. Using a light box (or a bright window) and coloured pencils or pens, trace the art details marked with solid grey lines from the templates on to the cardstock pieces.

7 Score the fold lines marked with dashed lines on the templates using a bone folder and metal ruler. Cut out all the pieces using scissors, following the outlines. Remove the templates from the cut and decorated pieces.

8 Glue the message panel on to the back pocket, and stick the wings in place at either side of the pocket using the tabs. Glue the chest to the front of the penguin. Fold the beak in half along the scored line so that the coloured marking is on the inside; apply a little glue to the back of the beak and stick it in the middle of the penguin's face. Glue the penguin's eyes above the beak and draw the eyebrows just above the outside edge of each eye. Apply glue to the top of the tabs on the penguin's feet and stick them in place.

CAROUSEL

Designed by: Tina Kraus

Capture the magic of childhood days with this merry-go-round card. This fantastic design is reproduced in full colour detail, ready to be enlarged and printed directly on to white cardstock. It makes the perfect birthday card for young children or fun-loving adults, and a great decoration for a child's room.

WHAT YOU NEED:

- Basic tool kit
- Three pieces of cardstock (160gsm) each 210 x 297mm (8¼ x 11¾in): one light blue, two white

1 Enlarge the templates on pages 122 and 123 to 100 percent using a photocopier. Print the base template on to the light blue cardstock and the carousel templates (1–4) on to the white cardstock. Cut out all parts and score along the fold lines.

2 Prepare the individual carousel pieces for assembly. To make the outer ring of the carousel, glue piece 1a to piece 1b, and then join the end tabs of the joined parts. To make the inner ring, glue the side tab in place on piece 2. To make the tent roof, overlap the green triangle on to the end tab and glue in place on piece 3. Glue the pieces of the golden tip (4) together and insert it into the top of the tent roof.

3 Glue the inner and outer rings on to the base, matching up tab A (on the inner ring) and tab B (on the outer ring) with the marked lines on the base.

4 Now with the carousel lying flat, glue the tent roof on to the upper tabs of the inner ring. Make sure that the tip doesn't jut over the edge of the card.

5 Coat tab C (on the inner ring) and tab D (on the outer ring) with glue (or use double-sided tape). Hold the carousel flat as you carefully close the other side of the base card on top of it. Firmly press the card with your hand, and then let it dry. When you open the card again, the carousel will magically pop up.

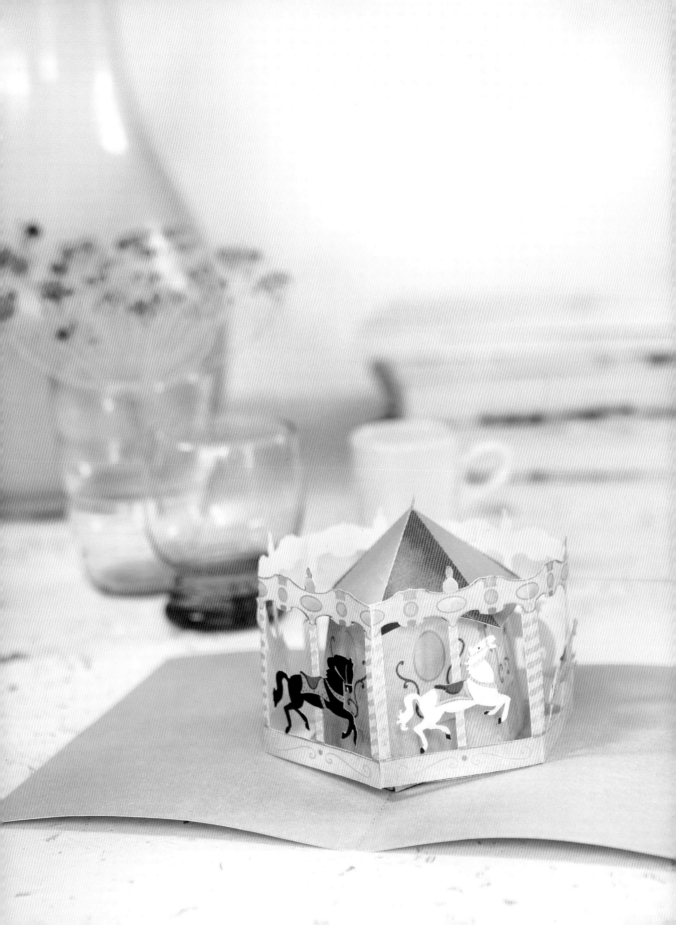

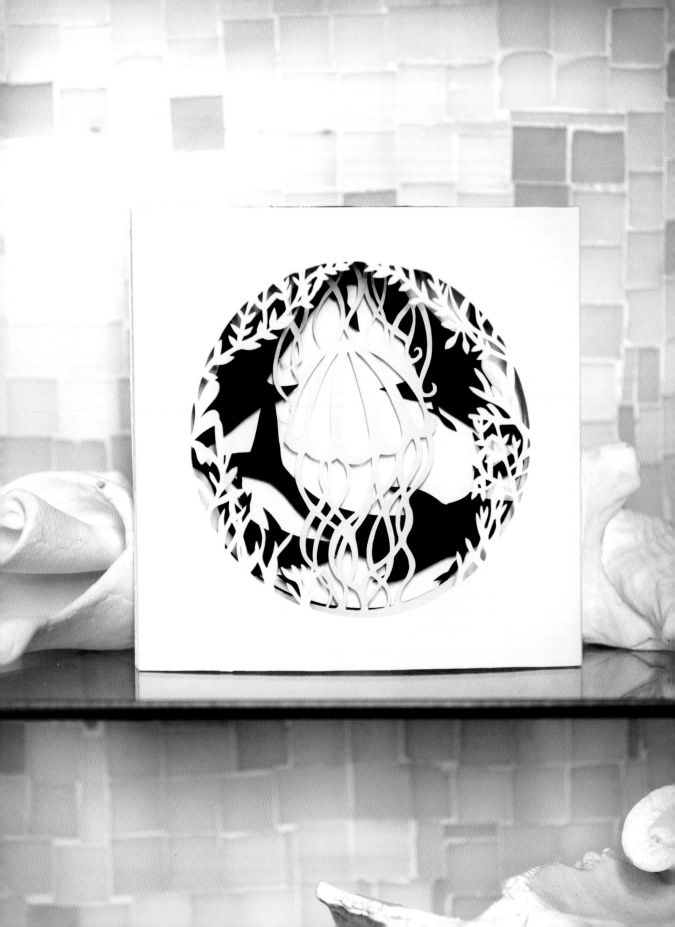

OCEAN TUNNEL

Designed by: Sarah Dennis

An underwater scene is viewed in three-dimensional detail in this beautiful card inspired by the tunnel book technique. The 'pages' or layers are held in place by two folded concertina strips, one on each side edge of the card, giving it the stability to stand on its own. Textured cotton paper is a good option for the paper cut designs.

WHAT YOU NEED:

- Basic tool kit
- One piece of cream cardstock (min. 160gsm) 210 x 297mm ($8^1/_4$ x $11^3/_4$in)
- One piece of light blue cardstock (min. 160gsm) 150 x 150mm (6 x 6in)
- Three pieces of paper (max. 160gsm) 148 x 148mm ($5^7/_8$ x $5^7/_8$in): one navy blue, one pale green, one cream

3 Lay the back panel cream-side-down on your work surface so that the light blue side is facing you. Run a thin line of glue (or double-sided tape) along the side edges and stick the concertina panels in place.

1 From the cream cardstock, cut out one 150mm (6in) square for the back panel and two rectangles each measuring 150 x 63mm (6 x $2^1/_3$in) for the side (concertina) panels. Glue the 150mm (6in) square of light blue cardstock to the cream cardstock square to complete the back panel.

2 Now mark the fold lines on the side panels. Use a ruler and pencil to measure and mark every $^1/_3$in (9mm) along the long edges of each piece. Draw faint pencil lines between the marked points, lightly score along the marked lines, and fold along the score lines to create two matching concertina-fold side panels.

4 Now prepare to make the paper cut pages. First enlarge the templates on pages 123 and 124 to 100 percent using a photocopier. Then attach the templates to the coloured paper sheets with small strips of invisible tape – the sharks to the navy blue paper, the jellyfish to the pale green paper and the coral to the cream paper.

5 Lay each prepared paper sheet on to a cutting mat in turn and carefully cut around the solid black lines using a craft knife. Remove each template and carefully remove the cut pieces of card from the design, releasing any uncut details with your craft knife.

6 Now fix the paper cut pages in place on the concertina side panels. Start by attaching the shark paper cut to the first fold. Add a thin line of glue (or double-sided tape) along the side edges of the paper cut page, and then attach it to the front of the concertina fold at the back of each side panel.

7 Repeat to attach the jellyfish paper cut to the middle concertina fold and the coral paper cut to the top concertina fold. Your tunnel book is now complete and will stand on its own.

SNAIL ON A LEAF

Designed by: Rosa Yoo

This little snail is full of character. His beautiful three-dimensional shell is created using parallel-fold struts. This card makes the perfect new-home greeting and, as it folds open to 180 degrees, it doubles as a decoration to brighten up a shelf. It has a tab-closing mechanism that holds it shut once closed, so you don't even need to use an envelope.

WHAT YOU NEED:

- Basic tool kit
- One piece of green cardstock (180–200gsm) 210 x 297mm (8¼ x 11¾in)
- One piece of yellow cardstock (160–180gsm) 210 x 297mm (8¼ x 11¾in)
- One piece of brown cardstock (160–180gsm) 100 x 150mm (4 x 6in)

1 Enlarge the templates on page 127 to 100 percent using a photocopier.

2 Transfer the leaf-shaped base template to the green cardstock and cut it out along the solid black outline. Use a craft knife and a metal ruler to carefully cut the slit (this will be used to hold the card closed). Fold the base template in half along the centreline and then open it again.

3 Use the snail body template to cut two snail bodies from yellow cardstock. Glue these together to double the snail's thickness, but leave the parallel-fold strips at the base of each body unglued. Use the antenna circle template to cut four circles from brown cardstock, and glue them in place on the antennae at the front and back of the snail's body.

4 To make the parallel-fold struts that help the snail stand on the base card, first score along the dashed lines. Fold up the parallel-fold strut on each side of the snail, applying a little glue to the final tab to stick it in place on the snail's body.

5 Glue the snail in place on the base card, positioning the parallel-fold struts on either side of the centreline fold, as marked on the template.

6 Now cut the pieces needed to make the snail shell: from the brown cardstock, cut two circles each using snail shell circle templates 1 and 3; and from the yellow cardstock, cut two circles each using snail shell circle templates 2 and 4, plus four snail shell parallel-fold struts.

7 Score the dashed fold lines on the snail shell parallel-fold struts and fold them up. These will be used to attach the snail shell circles in place on the snail's body. The larger rectangles (on both sides of the strut) are attached to the snail shell circles, and the smaller rectangles are attached to the base.

8 Add the circles one by one, sticking them to the parallel-fold struts. Start by gluing the large brown circles to the parallel-fold struts on either side of the snail's body. Glue a snail shell parallel-fold strut to the centres of the large brown circles, and then attach the largest of the yellow circles.

9 Attach the small brown circles using the remaining snail shell parallel-fold struts (see step 8), and then glue the small yellow circles directly to the centre of the small brown circles.

10 Cut two small leaves from green cardstock and stick them just below the slit on the base card. Cut the small branch from brown cardstock and glue it on the base card opposite the slit (see template for position).

11 To close the card, fold it up and slot the branch through the slit.

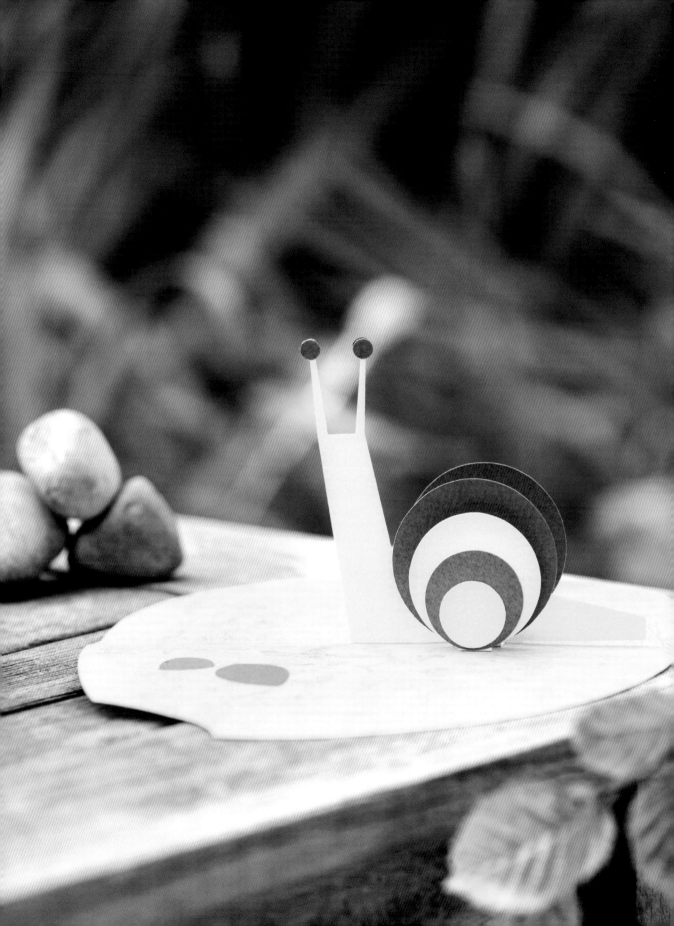

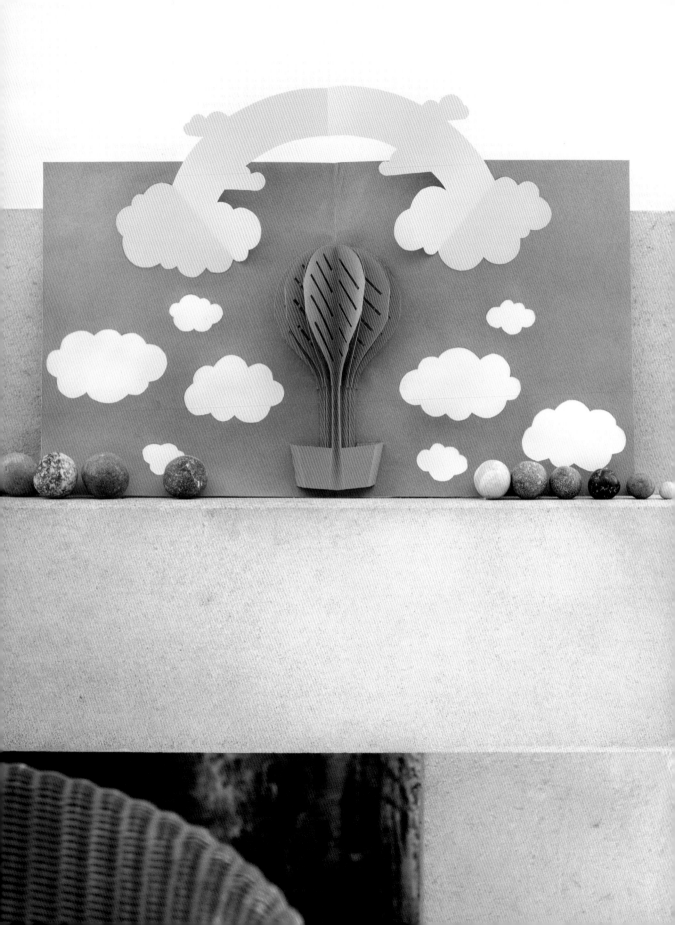

HOT AIR BALLOON

Designed by: Sabrina Giselle Acevedo

With its rainbow arch and sky filled with marshmallow clouds, this card captures the excitement of a hot air balloon flight with a design that looks great from any angle. This bright, whimsical card is perfect for a child's birthday or a farewell greeting.

WHAT YOU NEED:

- Basic tool kit
- One piece of bright blue cardstock (170–200gsm) 297 x 420mm (11³/₄ x 16¹/₂in)
- One piece of white cardstock (170–200gsm) 210 x 380mm (8¹/₄ x 15in)
- One piece of yellow cardstock (120–170gsm) 210 x 297mm (8¹/₄ x 11³/₄in)
- One piece of orange cardstock (120–170gsm) 180 x 360mm (7 x 14¹/₈in)

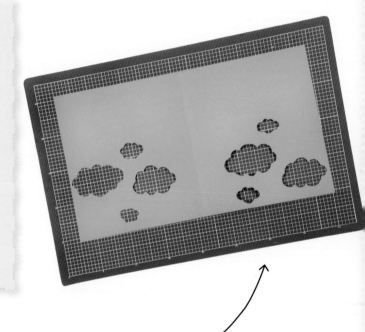

1 Enlarge the landscape template on page 125 to 100 percent using a photocopier and cut it out along the outer edges. Centre the template over the bright blue cardstock with a sheet of carbon paper placed in between, and attach the edges with small strips of invisible tape; then trace over the solid grey lines only. Unpeel the tape at one side of the template, carefully remove the carbon paper, and then re-fix the tape in place.

2 Using a craft knife on a cutting mat, carefully cut along the solid black lines through the template and the cardstock beneath. Remove the template. Fold the blue cardstock in half.

3 Take the white cardstock and fold it in half. Apply a thin, even layer of glue to the back of your blue cardstock panel; then stick it on top of the white cardstock, carefully matching up the centrelines and aligning them at the edges.

4 Enlarge the rainbow template on page 126 to 100 percent using a photocopier and print it directly on to the yellow cardstock. Cut out the rainbow along the solid black lines, and use a bone folder or the blunt edge of your craft knife and a metal ruler to score the fold lines. (Note: the back of the rainbow is seen in this photo.)

5 Enlarge the hot air balloon template on page 126 to 100 percent and print it directly on to the orange cardstock. Tape the cardstock on to a cutting mat and cut it out along the solid lines, using a craft knife and a metal ruler for the straight edges. Carefully remove the thin strips of card from the balloons, and then score the fold lines. (Note: the back of the hot air balloon piece is seen in this photo.)

6 Fix the rainbow in place on the blue cardstock: apply a thin, even layer of glue to the tabs marked A and line up the folds with the guidelines marked on the blue cardstock.

7 Fix the hot air balloon in place on the blue cardstock: apply a thin, even layer of glue to the tabs marked C and line up the folds with the guidelines marked on the blue cardstock. Repeat with the tabs marked B. Press the card firmly shut to enhance all the folds.

DAFFODIL

Designed by: Rosa Yoo

The lively, sunny colours of this spring-flowering daffodil card are sure to brighten up someone's day, no matter the time of year. The circular base of the card instantly sets it apart as something special and makes it perfect for mounting on a wall in a box frame.

WHAT YOU NEED:

- Basic tool kit
- Two pieces of cardstock (160–180gsm) 150 x 150mm (6 x 6in): one white, one yellow
- One piece of green cardstock (180–200gsm) 210 x 210mm (8¼ x 8¼in)
- Small piece of light green paper

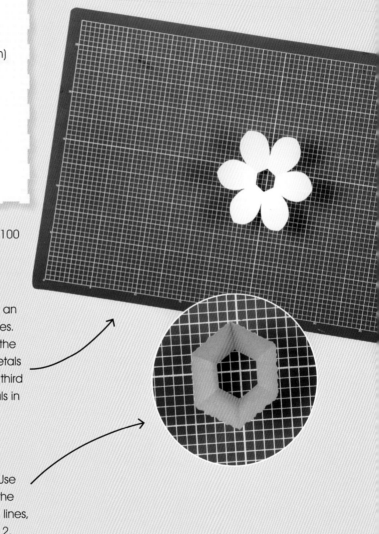

1 Enlarge all the templates on page 128 to 100 percent using a photocopier.

2 Use the outer petals template to cut the daffodil flower out of white cardstock. Use an embossing tool to slightly indent all the fold lines. Assemble the flower by gluing the end tab to the back of its neighbouring petal. Count three petals from the glued tab: the fold line between the third and the fourth petal is the spine; fold the petals in half along this spine.

3 Use the inner petals template to cut the daffodil trumpet out of yellow cardstock. Use scissors to cut roughly along the top edge of the petals for a more realistic look. Indent the fold lines, assemble, and fold the inner petals as in step 2.

4 Use the stamen and stamen circle templates to cut the stamens and stamen circle from yellow cardstock. Indent and fold all the fold lines, and use a craft knife and ruler to cut along the slits marked on the small circle. To join the stamen pieces, slide the small tabs at the bottom of the stamens into the slits on the stamen circle, and glue the tabs to the underside of the circle. Join the stamens together at the tallest point with a tiny dot of glue to make the pistil.

5 To assemble the flower, start by first joining the stamens and the inner petals. Place the inner petals upside down and fold back the bottom tabs. Take the assembled stamen piece and place a tiny spot of glue on the top of each tab. Place the stamen piece upside down into the base of the inner petals, and press the tabs together to fix them in place.

6 To complete the flower, attach the joined stamens/inner petals to the outer petals by gluing together the bottom tabs.

7 Use the base template to cut out the large circle from green cardstock. Indent along the dashed centreline and cut the slits on either side of this line. Fold the base card in half along the centreline and then open it again.

8 Slide the bottom tabs of the flower into the slits on the base, and fix them in place with a little glue.

9 Use the leaf template to cut a leaf from light green paper, and glue it to align with the centreline just below the flower.

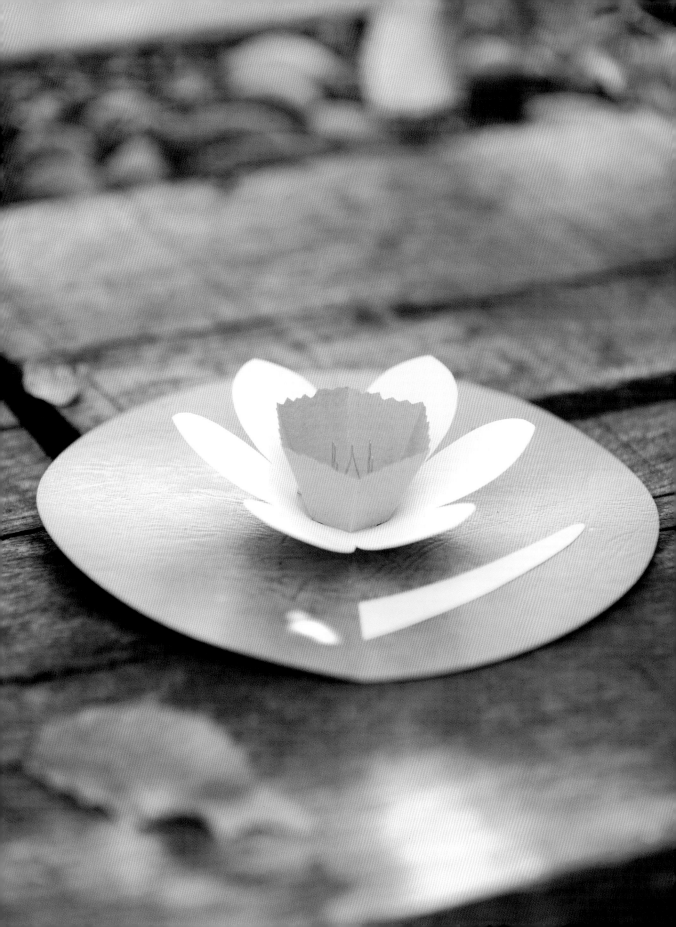

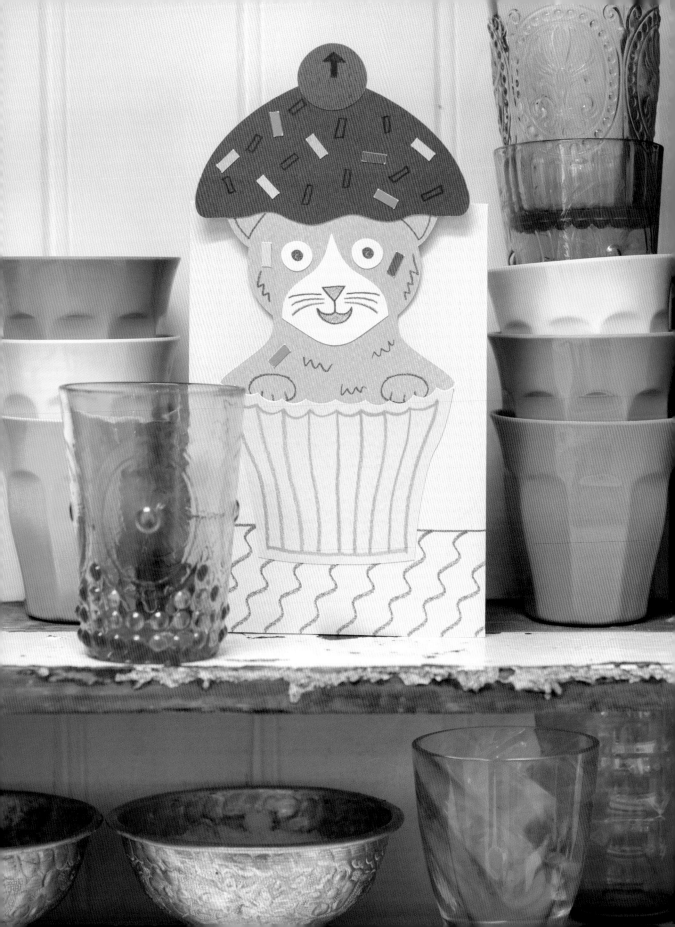

CUPCAKE KITTY

Designed by: Mary Beth Cryan

Pull the cherry on this cute little cupcake to find a cheeky kitten hiding inside, and then push it down again to hide her away. The surprise is made possible by the clever use of tabs to keep kitty in place. Children will love this design, but it will also appeal to cat lovers, although you might want to tone the colours down for an adult's birthday card.

WHAT YOU NEED:

- Basic tool kit
- One piece of light pink cardstock (200–250gsm) 390 x 178mm ($15^3/_8$ x 7in)
- Small pieces of cardstock (200–250gsm): purple, red, pink, yellow, green and white
- Coloured pens or pencils

1 Enlarge the templates on page 129 to 100 percent using a photocopier. Use scissors to cut out the templates following the black outlines.

2 Lay the light pink cardstock horizontally on your work surface with the front side facing up. Measure and mark at 127mm (5in) intervals along both long edges, starting from the left-hand side. Use a bone folder and a metal ruler to make three folds joining the marks from top to bottom. This will result in a small 9mm ($^3/_8$in) tab along the right-hand edge.

3 Turn the light pink cardstock over so that the tab is positioned on the left-hand side. Tape template A in the centre panel. Lay the card on a cutting mat and use a craft knife to cut through the slit only. Do not remove the template.

4 Attach the remaining templates to the back of the coloured cardstock pieces using small strips of invisible tape, as shown in the photo.

5 Turn the pieces of cardstock over. Using a light box (or a bright window) and coloured pencils or pens, trace the art details marked with solid grey lines from the templates on to the pieces of cardstock. Remember to mark the fold lines on the kitty body piece too. (The art on the templates is the reverse of the final version.)

6 Remove the template from the centre panel of the light pink cardstock, and turn it over (the tab is on the left-hand side). Fold the left-hand panel inwards. Glue the tab to the inside of the front cover to make the base card, creating a pocket to hide the pop-up.

7 Cut out all the remaining pieces using scissors, following the outlines of the template pieces. Remove the templates from the cut and decorated pieces. Setting the cupcake wrapper aside, glue all the pieces together to create the kitty, as shown in the photo.

8 Line up the top of the cupcake wrapper with the bottom edge of the slit on the front of the light pink base card; glue it in place (do not cover the slit).

9 Fold the tabs towards the back at either side of the bottom edge of the kitty, so you can slide it into the slit in the base card. Reach up through the bottom edge of the base card to unfold the tabs, keeping kitty in position.

10 Push kitty down into the cupcake wrapper to close the pop-up.

LET'S TRAVEL

Designed by: Rosa Yoo

This postcard-style card is perfect for a *bon voyage* keepsake. A tug on the pull-tab opens the suitcase to reveal the contents in fun X-ray style illustrations. You can easily adapt the choice of travel accessories to suit the planned trip.

WHAT YOU NEED:

- Basic tool kit
- One piece of dark cream cardstock (180–200gsm) 210 x 297mm (8¼ x 11¾in)
- One piece of light cream cardstock (180–200gsm) 80 x 180mm (3⅛ x 7in)
- One piece of red cardstock (160–180gsm) 148 x 210mm (5⅞ x 8¼in)
- Small pieces of cardstock (160–180gsm): grey, black and pink

1 Enlarge all the templates on page 130 to 100 percent using a photocopier. Use the base template to cut out the base sheet from dark cream cardstock. Score and fold all the fold lines. Lay the base sheet on a cutting mat and cut slits for the pull-strip as marked on the template.

2 Use the pull-strip template to cut out the pull-strip piece from light cream cardstock. Score and fold all the fold lines, and apply a thin, even line of glue to the top of the tab to complete the double-thick pull-strip.

3 Slot the pull-strip through the slits on the base sheet as shown. (Note: the narrow end of the strip is pulled up through the slit at the edge of the suitcase marking.)

4 Cut the suitcase cover from red cardstock and fold it in half. Open it up and place the left-hand panel of the suitcase cover on top of the suitcase marked on the base sheet, slipping it under the narrow end of the pull-strip. Apply a dot of glue under the pull-strip and stick it as marked on the suitcase cover.

5 Now apply a dot of glue to the top of the pull-strip, and refold the suitcase cover to hide it. Decorate the front of the suitcase cover with corners cut from grey cardstock. Make sure the suitcase opens when the side tab at the edge of card is pulled. Leave the tab pulled open as it is now time to make the suitcase base.

6 Use the templates supplied to cut out all the pieces you will need to complete the suitcase decoration – the suitcase base and large handle from red cardstock, the small handle from grey cardstock, the wheels from black cardstock, and the accessories from pink cardstock.

7 Glue the suitcase base, large handle and wheels to the marked positions on the base sheet. Stick the small grey handle on top of the large handle and glue the travel accessories to fill the suitcase base. Once the glue has dried, shut the suitcase cover.

8 Apply a thin line of glue to the narrow tab at the edge of the base card and stick the front and the back panel of the card together to hide the internal workings of the pull-strip mechanism. Cut a tiny triangle from red cardstock and glue it to the edge of the pull-strip.

YELLOW HOUSE

Designed by: Rosa Yoo

When this card is opened, a sweet little yellow house pops out, made possible by a clever combination of support struts. But don't worry – the mechanics have been worked out for you. To make this the perfect 'we are moving' announcement or 'welcome to your new home' card, simply change the colours to personalise it, or design your own decorations for the base card.

WHAT YOU NEED:

- Basic tool kit
- One piece of yellow cardstock (160–180gsm) 210 x 297mm (8$1/4$ x 11$3/4$in)
- Small pieces of cardstock (160–180gsm): red, bright blue, green and dark grey
- One piece of light grey cardstock (160–180gsm) 210 x 297mm (8$1/4$ x 11$3/4$in)

1 Enlarge all the templates on page 131 to 100 percent using a photocopier. Roughly cut out the individual parts and use them to cut out the required pieces from your cardstock as needed. Start by cutting the house, wall, T-shaped struts A and B, and I-shaped strut from the yellow cardstock. To do this, lay the cardstock on a cutting mat. Centre the templates on the cardstock and attach the edges with small strips of invisible tape. Using a craft knife and a metal ruler for the straight edges, carefully cut along the solid black lines through the template and the cardstock beneath, and then remove the template. Indent and fold all the fold lines as marked on the templates.

2 Cut the windows from red cardstock and glue them on to the house piece following the window placement guidelines – a pair of tweezers can help you to accurately place the windows. There will be one arched window remaining; glue this on to the wall piece as marked.

3 Now assemble the house. First attach the wall piece by sticking the left-hand side tab to the inside of the house piece towards the back. Fold the centreline of the wall inwards (valley fold) – see also the photo for step 4 on page 78.

4 Next, attach the I-shaped strut inside the back of the house, as shown.

5 Prepare the T-shaped strut for assembling the front of the house by gluing the T-shaped strut A to the T-shaped strut B.

6 Fold the end of the house around so that the front of the house begins to form. Glue the side tabs of the T-shaped strut to the inside of the front of the house, as shown in the photo. Finish the assembly by gluing all the remaining tabs together.

7 Cut the front and back roofs from bright blue cardstock, and attach them to the tabs along the roof line of the house.

8 Cut out the base from light grey cardstock and indent the centreline. Fold the card in half and then open it again.

9 Apply a thin, even line of glue to the tabs at the base of the house, and attach the house to the light grey cardstock following the guidelines.

10 Cut the treetops from green cardstock and the tree trunks from dark grey cardstock. Glue the trees in place to one side of the house.

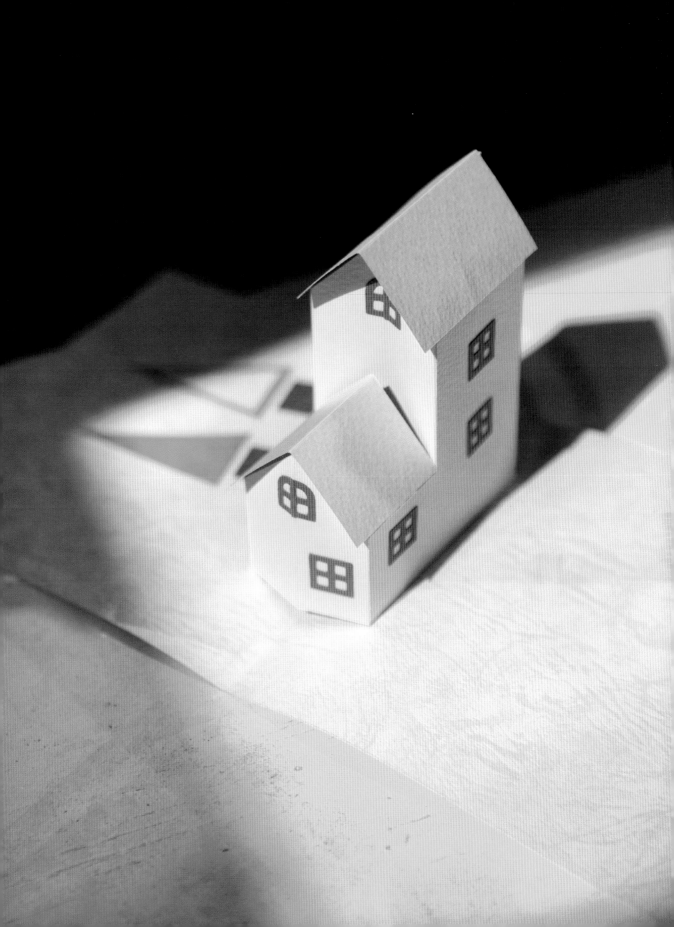

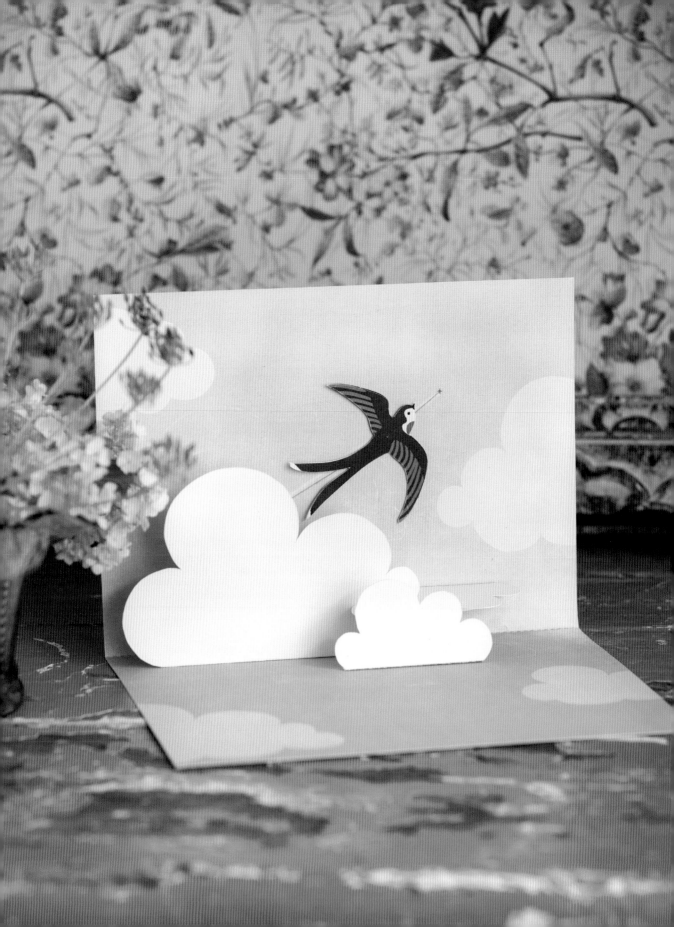

FLYING SWALLOW

Designed by: Tina Kraus

Pull the tab on the back of this card to send the swallow soaring up into the clouds. A delicate and beautiful card, this would be suitable for many occasions – including a graduation ceremony. The template provided is in colour, ready to be printed on white cardstock; however, you could replace the bird with a plane or a space rocket cut from a magazine.

WHAT YOU NEED:

- Basic tool kit
- Two pieces of white cardstock (160gsm) 210 x 297mm (8¼ x 11¾in)
- Sewing needle
- Light blue sewing thread

2 Thread the sewing needle with approximately 30cm (12in) of sewing thread. Thread the bird base on to the needle, pulling the needle through the upper hole only. Pull the bird through along the thread until there are about 10cm (4in) of thread remaining. Now thread the needle through the upper hole on the base.

3 Turn the base card over and thread the pull-tab. Loop the thread through the holes twice to fix the pull-tab firmly in place. Now pull the thread through the lower hole on the base card, making sure the pull-tab stays in position as shown (you can hold it temporarily in place with invisible tape).

1 Enlarge all the templates on page 132 to 100 percent using a photocopier and print directly on to the white cardstock. Cut out all parts and be sure to cut through the slots on clouds A and B. Fold all tabs as indicated along the dashed lines. Use the sewing needle to punch two tiny holes at the points marked on each of the following pieces: the top panel of the base, the pull-tab and the bird base.

4 Turn the base card to the front again and thread the needle through the lower hole in the bird base. Loop the thread through the holes twice to fix the bird on the lower end of the thread. Knot the ends of the thread together and cut off the thread tails.

5 Glue the pull-tab closed on the back of the card (remove the invisible tape if used), and on the front of the card, glue the swallow on to the bird base.

6 Now decorate the base card with the pop-up clouds. Starting with cloud A, apply glue to the base of the tab and stick it in place as marked on the base card. Repeat to fix cloud C in place.

7 Slot cloud B into cloud A so that it lies horizontally, and glue the upper (larger) tab in place as marked on the base card.

8 Finally, connect cloud B to cloud C by gluing the lower (smaller) tab in place on the back of cloud C.

9 Pull the tab on the back of the card so that the swallow hides behind the clouds, ready to surprise the lucky recipient.

HEART GIFT BOX

Designed by: Rosa Yoo

When this card opens to 180 degrees, the two sides of the heart slide seamlessly together to top the gift box with a love token. A mysterious valentine, an engagement party invite, or a first (paper) anniversary memento – the opportunities to show your love with this card are endless.

WHAT YOU NEED:

- Basic tool kit
- One piece of pink cardstock (160–180gsm) 148 x 210mm (5^7/$_8$ x 8^1/$_4$in)
- Small pieces of cardstock (120–160gsm): purple and gold
- Small piece of red cardstock (160–180gsm)
- One piece of light pink cardstock (180–200gsm) 210 x 297mm (8^1/$_4$ x 11^3/$_4$in)

1 Enlarge all the templates on page 133 to 100 percent using a photocopier. Roughly cut out the individual parts and use them to cut out the required pieces of cardstock as needed.

2 Start by cutting out the gift box template. Lay the pink cardstock on a cutting mat. Centre the gift box template on the cardstock and attach the edges with small strips of invisible tape. Using a craft knife and a metal ruler for the straight edges, carefully cut along the solid black lines through the template and the cardstock beneath, and then remove the template.

3 Decorate the centre panel of the cut-out gift box (which will become the sides of the box) with narrow gold cardstock strip borders and tiny purple squares to create a chequered pattern (see box decoration templates).

4 Indent the fold lines with an embossing tool: all are mountain folds, except for the diagonal valley fold line marked on the box top. Carefully fold along the fold lines and press with a bone folder to neaten.

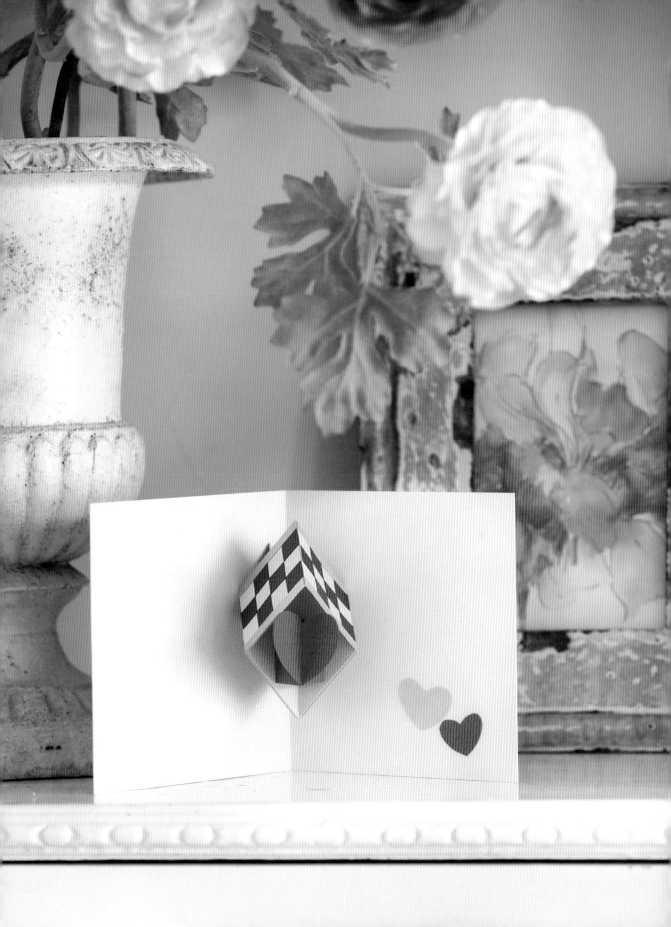

5 Now fold the decorated cardstock into the box shape, applying glue to the tab of the centre panel and the top panel to hold it in place.

6 Next, make the pop-up strut. Use the strut template to cut it from pink cardstock, indent the folds, and then fold and glue panel A on to the centre panel and panel B on top of panel A.

7 Attach the strut under the top of the gift box as shown, following the guideline marked on the template.

8 Make the pop-up heart. Use the heart template to cut the two parts of the heart from red cardstock, cut the slits marked on the template with a heavy black line, and indent and fold along the dotted lines. Slot the heart pieces together and fold the tabs towards each other. Apply a little glue under the tabs, and attach the heart to the diagonal fold on the top of the gift box as shown.

9 Use the base template to cut the base card from light pink cardstock. Fold it in half along the centreline and then open it again. Now attach the gift box to the positions marked on the base template. First, apply glue to just one of the gift box tabs and to the strut tab; then attach them to the base card. Now apply glue to the remaining gift box tab, close the base card on to the unfolded box and press firmly.

10 Once the glue has dried, open the card to reveal the pop-up. You can decorate the base card with small hearts cut from red and pink cardstock.

SUNDAY DRIVER

Designed by: Rosa Yoo

To drive in a convertible car is one of the most liberating sensations in the world, but be careful not to lose your scarf to the wind like this Sunday driver. This design makes an ideal birthday card for a friend. You can personalise it by changing the car model or colour to match the recipient's preferences, or make the silhouette look like her (or him!).

WHAT YOU NEED:
- Basic tool kit
- One piece of turquoise blue cardstock (180–200gsm) 210 x 297mm (8¼ x 11¾in)
- Small pieces of cardstock (160–180gsm): pink, yellow, black, light grey and white

2 Use the scarf templates to cut the two scarf pieces from pink cardstock, carefully cutting out the decorative detail on each. Score and fold the lines on the larger scarf template, taking care to fold valley or mountain folds as marked. Use a drop of glue to attach the smaller scarf piece at an angle to the back of the larger scarf piece.

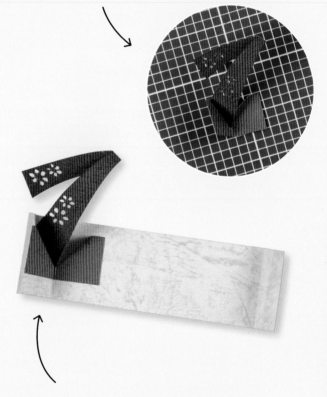

1 Enlarge all the templates on page 134 to 100 percent using a photocopier. Use the parallelogram template to cut a rectangular strip from the turquoise blue cardstock. (Note: this will form a parallelogram shape when it is attached to the base card.) Score and fold all the dashed lines marked on the template as valley folds. Be sure to mark the grey lines on the card as these serve as your guide for positioning the pop-up scarf.

3 Glue the assembled scarf in place on the parallelogram strip, positioning it on the marked guidelines.

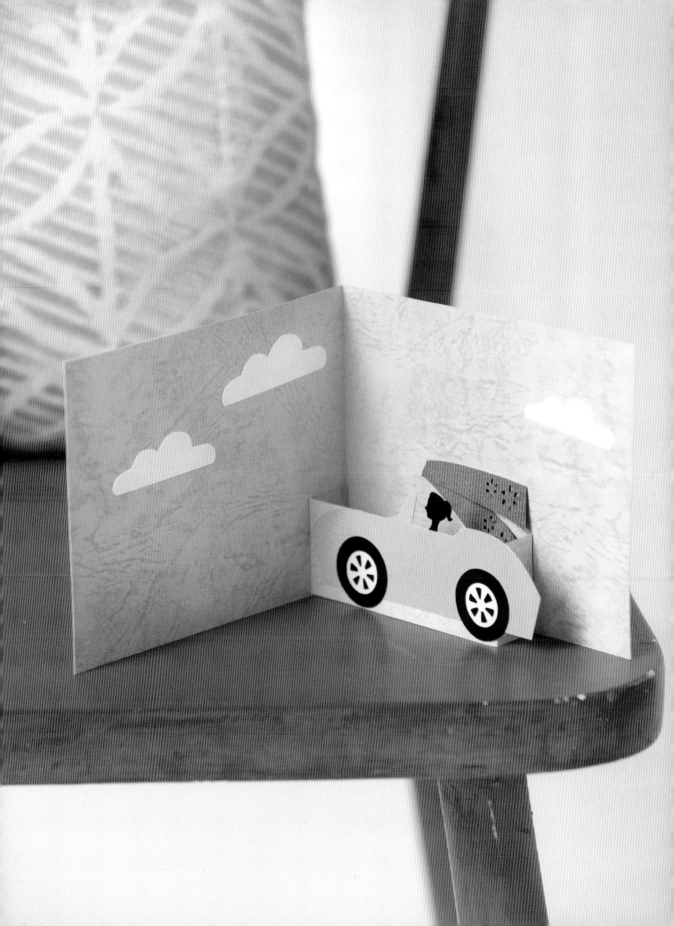

4 Use the base template to cut a piece of turquoise blue cardstock and fold it in half to make the base card. Apply a thin, even line of glue to the tabs at either side of the parallelogram strip and fix it in place on the base card in the positions marked on the template. Make sure the scarf pop-up moves smoothly when the card is opened and closed.

5 Now cut and assemble the sports car. Use the relevant templates to cut out a sports car from yellow cardstock, the driver and two tyres from black cardstock, and two hubcaps from light grey cardstock. Glue the driver in place behind the wheel of the sports car, angling the head backwards slightly. Glue the sports car in place on top of the parallelogram; avoid getting glue on the side of the parallelogram. Glue the tyres in place and the hubcaps on top of the tyres. Use the cloud template to cut three clouds from white cardstock, and glue them across the sky to decorate the base card.

HILLSIDE VILLAGE

Designed by: Rosa Yoo

Inspired by the hillside villages of Italy, this multilayered pop-up is a little more challenging than most, but it is sure to impress. There are three layers, each consisting of two houses decreasing in size, giving the impression of a settlement nestling into the hills. If you wish, you can adapt the colour and decorations of the houses to suggest the architecture of different countries.

WHAT YOU NEED:

- Basic tool kit
- One piece of white cardstock (160–180gsm) 210 x 297mm (8¹/₄ x 11³/₄in)
- Small pieces of cardstock (160–180gsm): red, green and brown
- One piece of navy blue cardstock (180–200gsm) 210 x 297mm (8¹/₄ x 11³/₄in)

1 Enlarge the templates on page 135 to 100 percent using a photocopier. Roughly cut out the individual parts and use them to cut out the required pieces from your cardstock as needed, using a craft knife on a cutting mat.

2 Cut the two big houses from white cardstock. First, cut around the outlines, and then cut out the window apertures. Cut the window frames and roofs from red cardstock and glue them in place. Cut away the slots at the side edges, and fold all the dotted lines using a bone folder.

3 Join the houses together by gluing tab A to tab B, as shown in the photo. You have now completed house layer 1.

4 Now make the tree struts to support layer 1, using one for each house. Cut the treetops from green cardstock and the tree trunks from brown cardstock. Cut away the slots on the tree trunks, and score the fold lines using a bone folder. Slot the treetops into the trunks and glue them in place. Slightly fold the two small wing tabs at the top and bottom edges of the tree trunks.

5 Push the side tab on the tree trunk into the slot on the house and unfold the two small wing tabs to hold it in place.

6 Now make layer 2 using the middle-sized house template and the tree templates for layer 2, following steps 2–5.

7 Make layer 3 using the small-sized house template, following steps 2–3. (Note: this layer has no tree struts, so there are no slots to be cut.)

8 Now to assemble the three layers. First, place layer 1 on your work surface. Then apply glue to the back of the centre strut on layer 2, and glue it in the marked position on top of layer 1 so that the centre struts of each layer align. Apply glue to the back of each tree strut on layer 2, and attach it to the marked position on layer 1.

9 Glue layer 3 on top of layer 2, first aligning the centre strut and then sticking the side struts in the marked positions on layer 2.

10 Cut the base template from navy blue cardstock. This is your base card. Fold it in half, flatten the fold with a bone folder, and then open it again.

11 Now attach the layered village to the base card. First, glue the centre strut of layer 1 to the position marked at the centre of the base. Then glue each of the tree struts on layer 1 to the positions marked on each side of the base card. Close the card and press it firmly. Open the card to reveal your village.

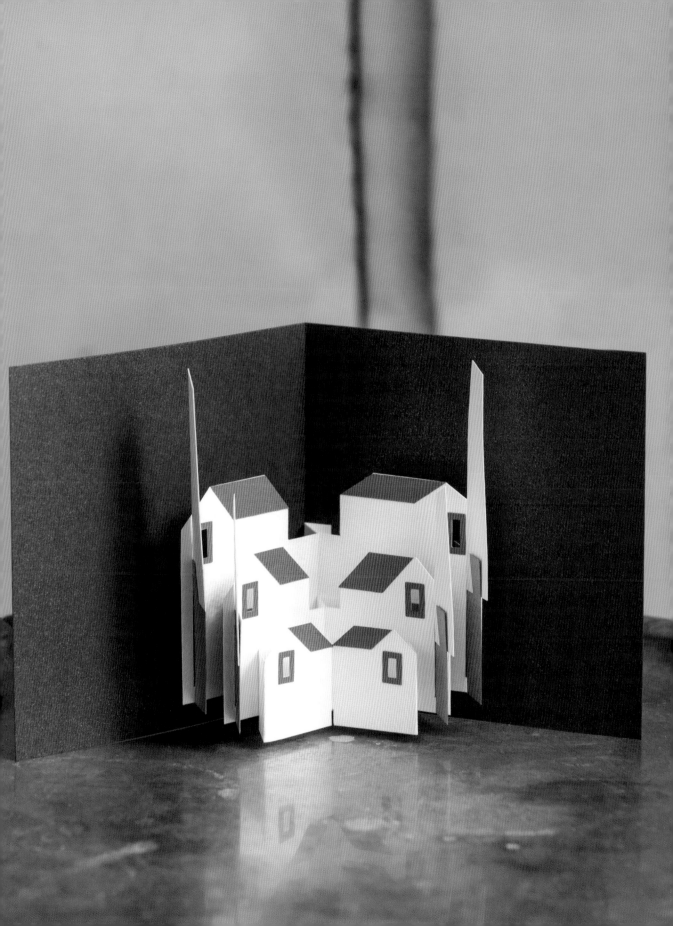

WINGED DRAGON

Designed by: Kyle Olmon

Open the card to find a resting dragon, but pull its tail and it will fly! This is an intricate and finely detailed card that will develop your paper-engineering skills. The reward of bringing this mythical beast to life will be worth the challenge. You can colour the dragon pieces with felt-tip pens or print them on to coloured cardstock.

WHAT YOU NEED:

- Basic tool kit
- Two pieces of cardstock (200gsm) 210 x 297mm (8¼ x 11¾in): one brown, one white

1 Enlarge the templates on page 136 to 100 percent using a photocopier, and print the base template on to the brown cardstock and the dragon pieces on to the white cardstock.

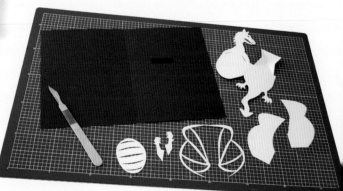

2 Using a craft knife or scalpel and a metal ruler for the straight edges, carefully cut out all the pieces along the solid black lines (but do not cut out the shaded box on the base template). Use a metal ruler and a bone folder to score and fold the centreline on the base, the centreline on the dragon's body piece, and the folds of the pop-up tab. Open the base and unfold the dragon body piece at the centreline.

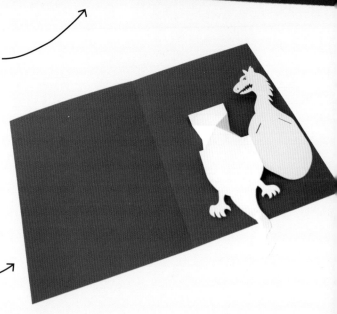

3 Apply a thin layer of glue to the shaded rectangle marked on the base. Turn the dragon's body over and attach the top tab of the pop-up to the glued area. Press firmly for twenty seconds to allow the glue to dry.

4 Apply a thin layer of glue along the underside of the wing ribs. Line them up with the edges of the wing pieces and press firmly for twenty seconds to allow the glue to dry. To fix the wings in place, apply glue to the upper triangles of the pop-up tab on the dragon body piece, and line up each wing with the bottom edge of the triangles before pressing firmly in place.

5 Apply glue to the area above the dragon's feet and below the folded pop-up tab area, and then carefully fold down the dragon's head and chest on to the glue. Take your time and line up the edges before pressing firmly in place, otherwise the arms may fail to work. Press for twenty seconds to allow the glue to dry.

6 Apply a thin layer of glue to the underside of the belly piece and attach it to the dragon's chest.

7 Next, glue the arms in place, starting with the right arm. Apply a dot of glue to the lower left-hand triangle on the pop-up tab on the dragon body piece. Line up the right arm with the outer edge before carefully inserting the right arm through the slot on the dragon's chest, attaching it to the glued lower triangle. Repeat to attach the left arm to the lower right-hand triangle.

8 Push up the dragon's tail to make the wings fold down and the arms rise up as shown. Then close the card and press firmly for twenty seconds to flatten the pop-up. When you open the card and pull on the dragon's tail, the dragon will fly.

CHAPTER 3

DISCS & SPIRALS

In this final chapter, you'll explore how circular shapes and rotating discs can add another dimension to your pop-ups. Two of the projects, Exploding Robot (page 100) and Bird in a Cage (page 113), use a simple spiralling technique in quite different ways. Or, if you prefer, you can explore the world of rotary mechanisms to make exciting interactive details – turn the disc on the Spinning Flowers card (page 104) to reveal its hidden colours and make the sails of the Dutch Windmill (page 108) spin.

When cutting circles with a craft knife, cut your paper gently and slowly, and take time to practise your technique. If you plan on exploring these skills, you may find a circle cutter a helpful tool. It works in much the same way as a mathematical compass does, except instead of the pencil, it has a cutting blade, and it will cut an exact circle. To cut a spiral with a circle cutter, gradually move it outwards from the centre to avoid tearing your paper.

EXPLODING ROBOT

Designed by: Mary Beth Cryan

When the door on the front of this friendly robot is opened, a simple spiral explodes to life, with gears bursting out from deep inside. This great card delivers quite a surprise for the birthday boy or girl, and it makes a fun party invitation. The robot will sit happily on a table or a shelf when its legs are folded and its body is left open.

WHAT YOU NEED:
- Basic tool kit
- One piece of light orange cardstock (200–250gsm) 210 x 297mm (8¼ x 11¾in)
- Small pieces of cardstock (200–250gsm): bright blue, dark orange and grey
- Coloured pencils

1 Enlarge the templates on page 137 to 100 percent using a photocopier. Use scissors (or a craft knife and metal ruler) to cut out the templates following the solid black outlines, and then tape them to the back of the coloured cardstock, as shown in the photo.

2 Turn the pieces of cardstock over. Use a light box (or a bright window) and coloured pencils or pens to trace the art details marked with grey markings from the templates on to the cardstock. You will notice that the art on the templates is the reverse of the final version so that it will appear as it does on the final card when traced. Score the dashed lines marked on the robot body and arm templates using a bone folder and metal ruler.

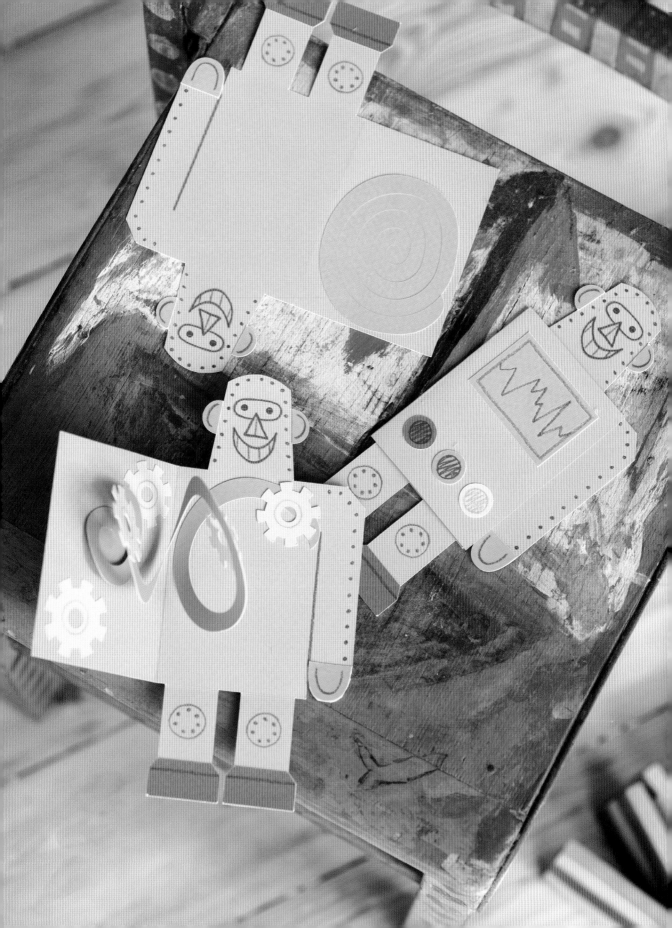

3 Cut out all the pieces following the outlines of the templates. Remove the templates from the cut and decorated pieces. Set aside the blue spiral and the grey gears, and then glue all the remaining parts on to the robot's body and arm, as shown in the photo.

4 With the robot front facing down, position the arm piece so that the round tab is positioned against the right-hand shoulder on the back of the robot and the hand is positioned in front. Glue the tab in place, and then turn the robot to the front and glue the arm in place.

5 Place a small dot of glue at the very centre of the spiral. Open the flap on the robot's body and position the spiral inside, as shown in the photo. Press the centre of the spiral into place and wait until the glue has dried before proceeding.

6 Place a small dot of glue on the very end of
the spiral, close the flap and press down on
the area where the edge of the spiral is positioned.
Do not open the card until the glue has dried.

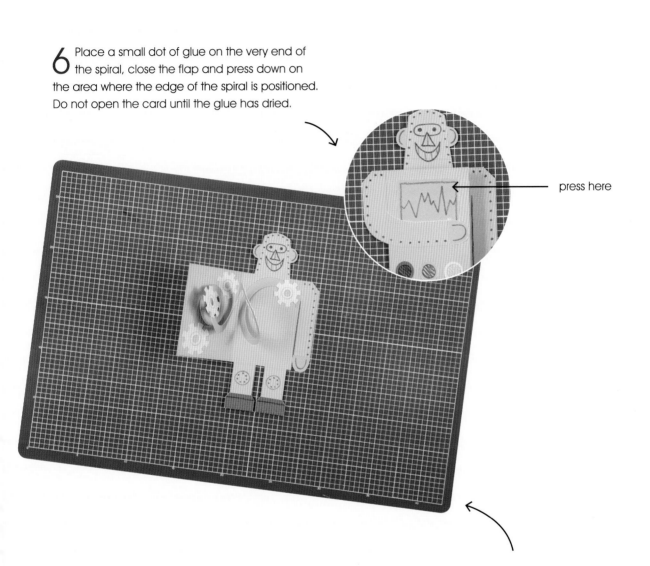

press here

7 Once the glue has dried, open the flap and
glue the gears into place to complete the
exploding robot.

SPINNING FLOWERS

Designed by: Sabrina Giselle Acevedo

This card is decorated with ornate, lacy floral circles that are beautiful, but the magic really happens when you spin the discs at either end. The colours blend to dazzle your eyes with a swirling effect. It is easy to adapt this design to suit the season – you could cut a wreath of leaves and choose a palette of rich oranges, browns and reds to match autumn colours.

WHAT YOU NEED:

- Basic tool kit
- Two pieces of cardstock (170–200gsm) 297 x 420mm (11³/₄ x 16¹/₂in): one rose pink, one dark pink
- Two pieces of cardstock (150–200gsm) 210 x 297mm (8¹/₄ x 11³/₄in): one yellow, one lilac
- Four pieces of cardstock (120–170gsm) 140 x 140mm (5¹/₂ x 5¹/₂in): one blue, one violet, one light pink, one green
- One piece of dark pink cardstock (170–200gsm) 140 x 260mm (5¹/₂ x 10¹/₈in)

2 First, lay the piece of rose pink cardstock on a cutting mat. Centre template E on the cardstock and attach the edges with small strips of invisible tape. Using a craft knife, or scalpel, and a metal ruler for the straight edges, carefully cut along the solid black lines through the template and the cardstock beneath.

3 Carefully peel back the template at one edge, place carbon paper between the template and the cardstock, and copy the flower guideline (shown as a solid grey line) in the centre of each circle on to the cardstock. Remove the template.

4 To complete the front panel, trim 5mm (¹/₄in) from the side edges (excluding the indented areas); use the blunt edge of the craft knife and a metal ruler to score and fold a line 5mm (¹/₄in) from the long edges to make tabs.

1 Enlarge the templates on pages 138 and 139 to 100 percent using a photocopier, and cut out six templates (A to F). Make an additional copy of templates A and E. (Note: for the second copy of template E, the outer edge and centreline fold are the only required elements.)

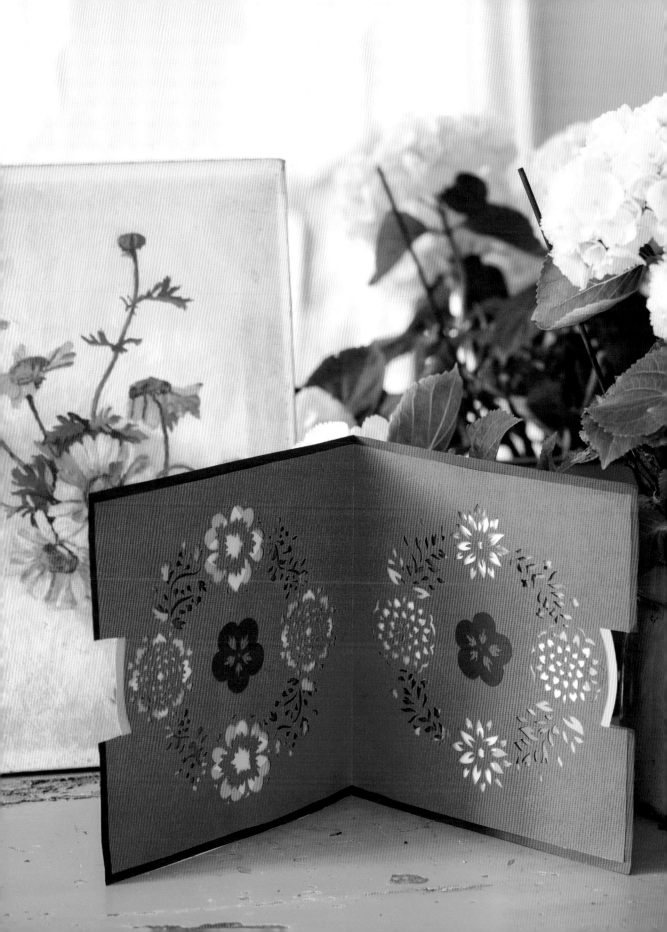

5 Repeat step 2 to cut the second copy of template E (without flower circle designs) from the large piece of dark pink cardstock. This is the back panel of the card.

6 Repeat the method described in steps 2 and 3 to cut template A from both the yellow and the lilac cardstock. These are the rotating discs.

7 Now lay the blue cardstock on your cutting mat. Centre template B on the cardstock and attach the edges with small strips of invisible tape. Use a craft knife to cut along the solid black lines through the template and the cardstock beneath. Remove the template and you will have four blue four-petal flowers. Repeat this step to cut four flowers from the green, light pink and violet cardstock pieces.

8 Apply a thin, even layer of glue over the back of the green and violet flowers, and stick them over the flower guidelines marked on the yellow disc, alternating the colours. Repeat to fix the blue and light pink flowers in position on the lilac disc.

9 Lay the small piece of dark pink cardstock on your cutting mat. Place template C (pivot circles) and template D (joining circles) on the cardstock and attach the edges with invisible tape (position the templates so sufficient cardstock is left to cut template F in step 11). Use a craft knife to cut along the solid black lines through the template and the cardstock beneath. Use the tip of the knife to pierce the dotted line that marks the fold lines on the pivot circle tabs. Remove the templates. Score the fold lines on the pivot circles, and fold up the tabs to make the pivots.

pivot circle joining circle

10 The pivot and joining circles are used to attach the rotating discs to the back of the flower circles (front) panel. Place the front panel so that the side with the flower guidelines is face down. Apply glue to the back of one of the pivot circles to attach it to the exact centre of one of the cut-out flower circles. Next, thread the tabs of the pivot circle through the hole of a rotating disc (make sure the decorated side of the disc is face down). Apply glue to the pivot circle tabs (do not get glue on the disc), and stick the joining circle in place on the tabs.

11 Repeat step 10 to attach the second disc to the back of the remaining flower circle paper cut. Use template F to cut two flowers from dark pink cardstock. Glue these flowers on top of the guidelines marked on the front of the flower circles panel.

12 Now join the back panel to the flower circles (front) panel. First, fold each panel in half and open them again. Apply a thin, even layer of glue (or double-sided tape) along the edge of the back of the flower circles panel, and attach it to the top of the back panel. Again, be very careful not to get glue on the rotating discs. Once the glue has dried, fold the card closed.

DUTCH WINDMILL

Designed by: Rosa Yoo

Open this card and a quaint Dutch landscape pops up – and it is full of interactive fun! Spin the sails of the windmill using the rotating disc technique, and pull the tab to move the wheelbarrow back and forth in front of the barn. Once you've learned these techniques, you can adapt them to create moving parts in your own card designs.

WHAT YOU NEED:

- Basic tool kit
- One piece of red cardstock (160–180gsm) 148 x 210mm (5^7/$_8$ x 8^1/$_4$in)
- Small pieces of cardstock (160–180gsm): grey and brown
- One piece of olive green cardstock (160–180gsm) 148 x 210mm (5^7/$_8$ x 8^1/$_4$in)
- One piece of white cardstock (160–180gsm) 210 x 297mm (8^1/$_4$ x 11^3/$_4$in)
- One piece of light green cardstock (180–200gsm) 210 x 297mm (8^1/$_4$ x 11^3/$_4$in)

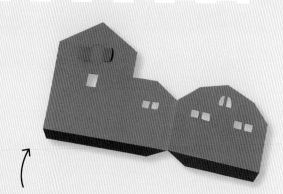

1 Enlarge the templates on pages 140 and 141 to 100 percent using a photocopier. Roughly cut out the individual parts and use them to cut out the required pieces from your cardstock as needed, using a craft knife on a cutting mat.

2 Cut out the windmill house from red cardstock. First cut out around the outlines, and then cut out the window apertures and the hole for the windmill sails. Score and fold along the dotted lines. Cut out the pivot from red cardstock, cutting all the solid black lines and gently scoring along the dashed lines for the wing tabs. Slightly fold the wing tabs, but only just enough to be able to push them through the hole from the back of the house; then unfold them on the front of the house.

3 Next, assemble the windmill sails. Cut one joining circle from red cardstock and two windmill sails from brown cardstock. Glue the windmill sails together to double their thickness. Glue the sails on to the joining circle (see photo). Attach the sails to the house: apply a tiny dot of glue to each wing tab on the pivot and glue the joining circle in place; be very careful to get glue only on the wing tabs of the pivot or the sails will not spin freely.

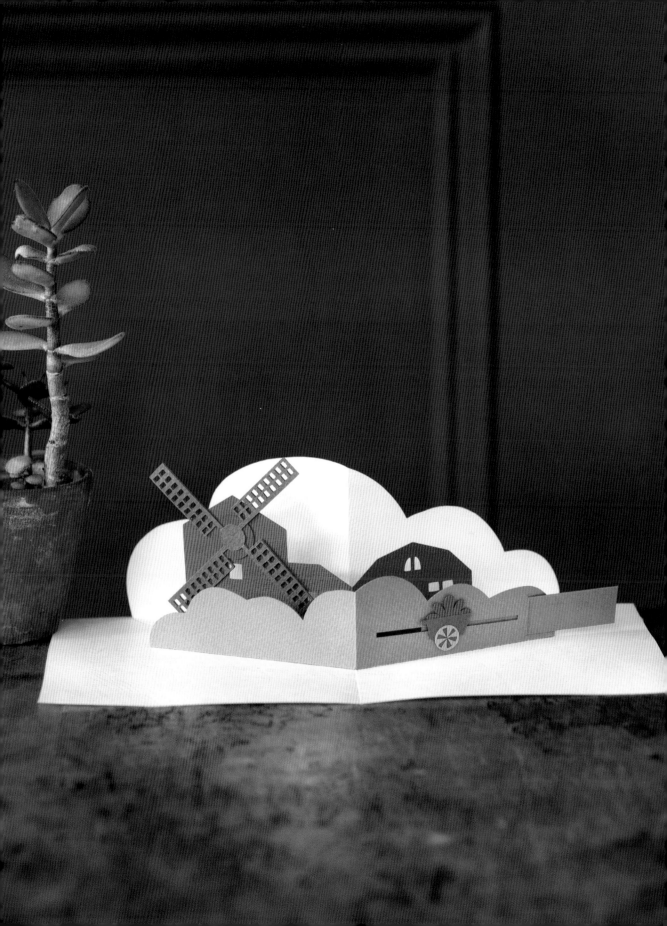

4 Cut out the small pieces required for the wheelbarrow and glue them together, as shown in the photo.

5 Cut the grass from the olive green cardstock, remembering to cut out both the long slot and the slit on the right-hand side for the wheelbarrow pull-strip. Score the fold lines.

6 Cut the pull-strip pieces from olive green cardstock and score the fold lines. Fold the large green strip along the centreline to make it double thickness. Fold the two small rectangles in half. If you look very closely, you will see that one half of each rectangle is slightly longer. Put a drop of glue on to the base of the longer halves, and stick them in the marked positions on the pull-strip so that the shorter halves are facing towards each other (see photo). These are the tabs to which the wheelbarrow will be attached in step 8.

7 Once the glue has dried, place the pull-strip behind the grass piece, squeeze the wheelbarrow tabs together to slip them through the slot in the grass, and then let them open out again. Slip the other end of the pull-strip through the slit at the other end of the slot to create the pull-tab.

8 Glue the wheelbarrow on to the wheelbarrow tabs; make sure that, when you use the pull-tab, the wheelbarrow glides across the grass.

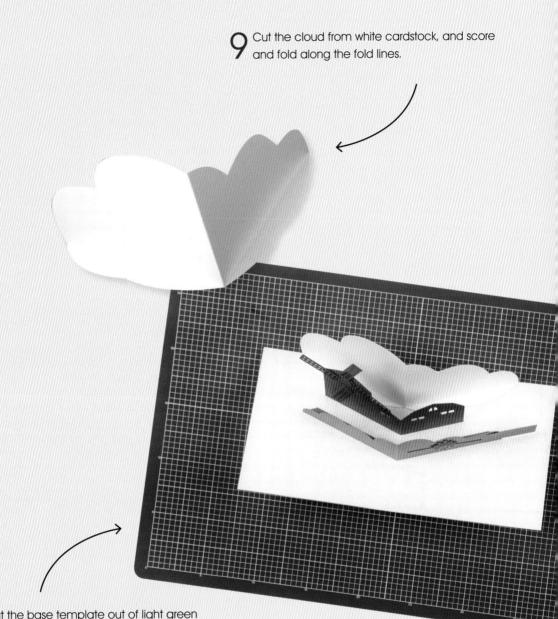

9 Cut the cloud from white cardstock, and score and fold along the fold lines.

10 Cut the base template out of light green cardstock and score the centreline. Fold the base card in half and then open it again. Apply glue to the tabs at the base of the cloud, windmill and grass pieces, and attach them to the base card following the guidelines, starting with the cloud piece at the back and finishing with the grass piece in the foreground.

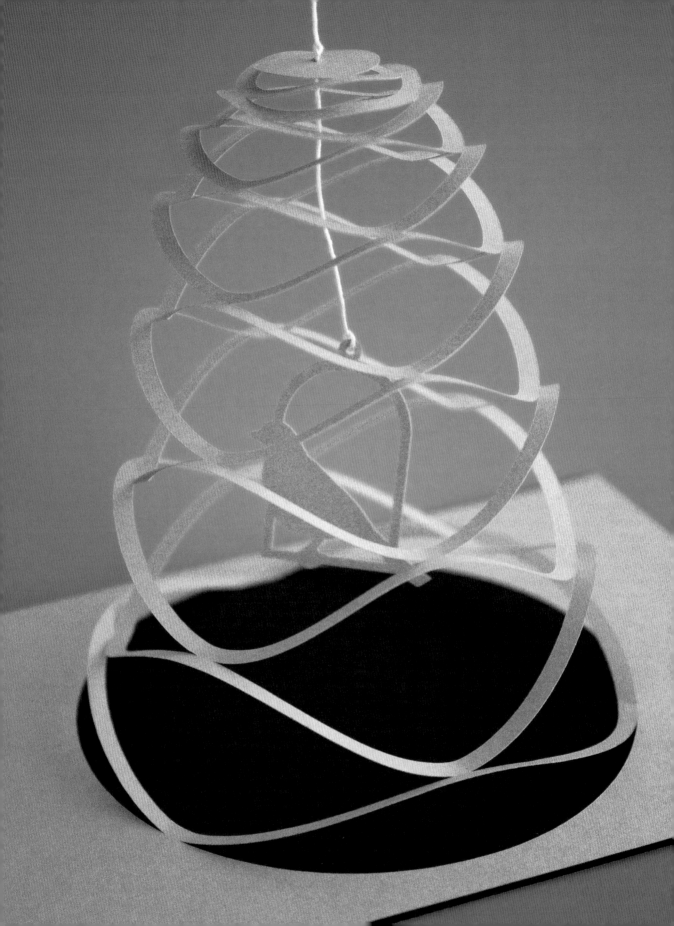

BIRD IN A CAGE

Designed by: Kyle Olmon

When this card is opened, all that can be seen is a small piece of string at its centre. Pull the string up and the apparently flat card transforms into a beautiful birdcage that contains a pretty little bird sitting on its perch. For even more impact, you could add a piece of coloured card behind the birdcage panel.

WHAT YOU NEED:

- Basic tool kit
- Circle cutter (optional)
- One piece of navy blue cardstock (200gsm) 185 x 260mm ($7^1/_4$ x $10^1/_4$in)
- One piece of yellow paper (75–90gsm) 210 x 297mm ($8^1/_4$ x $11^3/_4$in)
- Large sewing needle
- String or yarn

1. Lay the navy blue cardstock on a cutting mat and score a line down the middle using a metal ruler and the blunt edge of your craft knife. Fold the card in half to make your base card.

2. Enlarge the templates on page 141 to 100 percent using a photocopier and print them on to the yellow paper. Lay the paper on to the cutting mat and use a craft knife to carefully cut along all the solid black lines, from both the cage template and the bird on a perch template.

3. Use a needle to pierce through the loop at the top of the bird on a perch piece. Thread the yarn through the loop and tie a knot. Tie a second knot 5cm (2in) from the first knot.

4 Thread a needle on to the yarn and pierce through the cross marked at the centre of the cage piece, bringing the yarn through to the other side.

5 Tie a final knot close to the exit point of the needle to secure the yarn in place. Remove the needle.

6 Turn the cage piece over to the side that has the bird piece hanging down (adding a small strip of invisible tape to the knot, as shown, gives greater stability). Apply a thin, even layer of glue along the edges of the cage piece; be very careful not to get any glue on the circular cut-out.

7 Open the base card and attach the glued cage panel to the right-hand side. Close the base card, press firmly and wait twenty seconds for the glue to dry. When the string is pulled up, the bird will be revealed.

TEMPLATES

KEY:

——— cut line

········· placement/ decoration line

– – – – valley folds
　　　V

············ mountain folds
　　　M

NOTE: For advice on enlarging and using templates, see page 13.

POT OF FLOWERS: page 18 (shown at 50%)

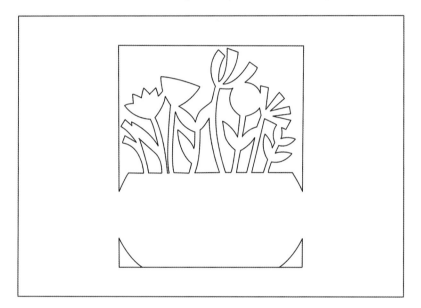

WEDDING BIRDS: page 16 (shown at 50%)

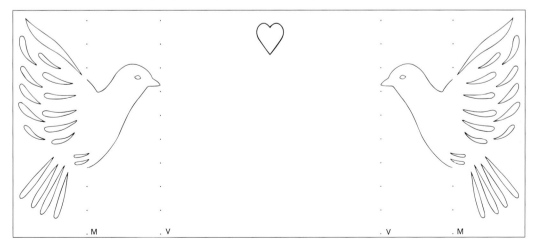

FIESTA: page 21 (shown at 50%)

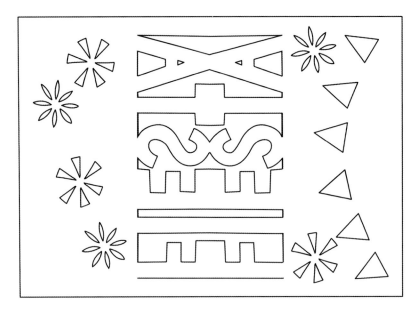

BIRD BOX: page 24 (shown at 50%)

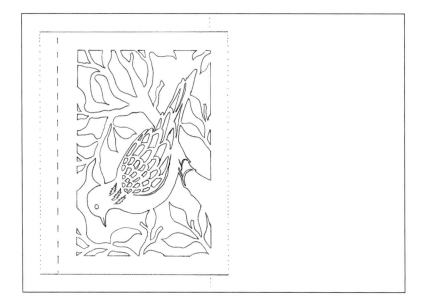

KNIGHT'S FORTRESS:
page 27 (shown at 50%)

FOX ON THE HILLSIDE:
page 28 (shown at 50%)

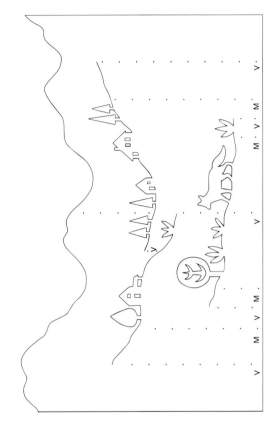

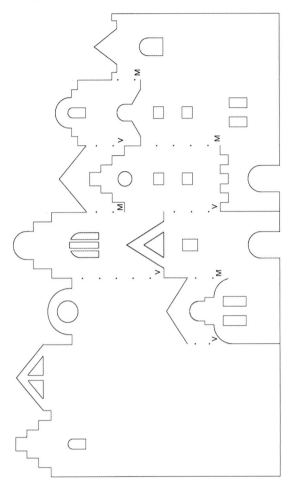

WREATH HEART: page 31 (shown at 50%)

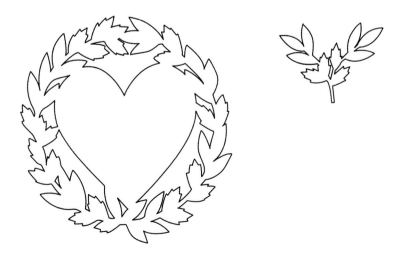

BIKE RIDE: page 34 (shown at 50%)

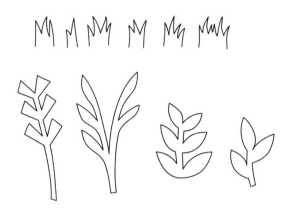

BEE & HONEYCOMB: page 37 (shown at 50%)

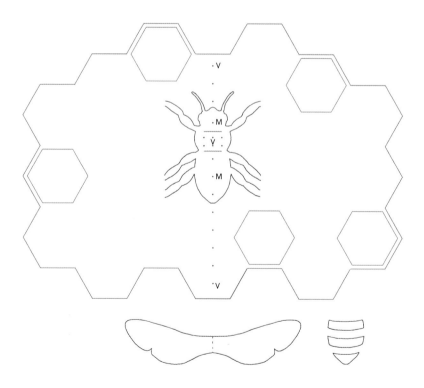

MEDIEVAL CASTLE: page 41 (shown at 50%)

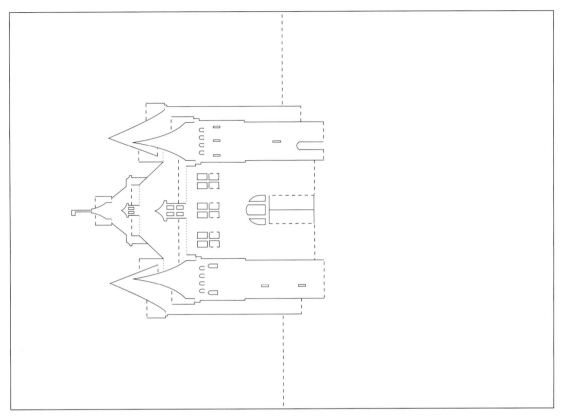

WATER LILIES: page 47 (shown at 50%)

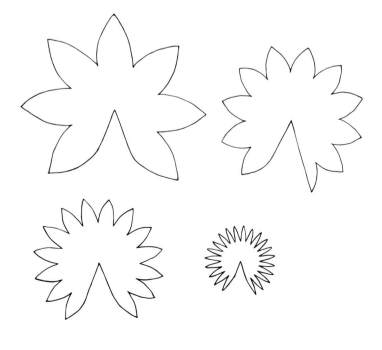

CHRISTMAS TREE: page 43 (shown at 50%)

tree

base

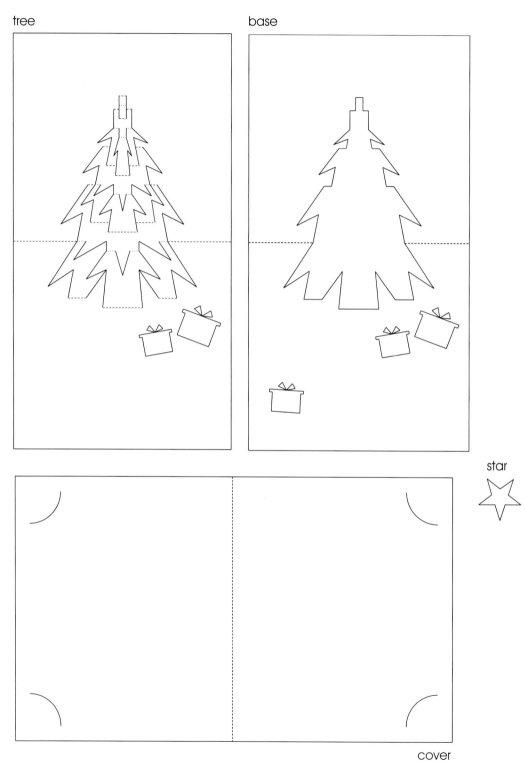

star

cover

PENGUIN: page 52 (shown at 50%)

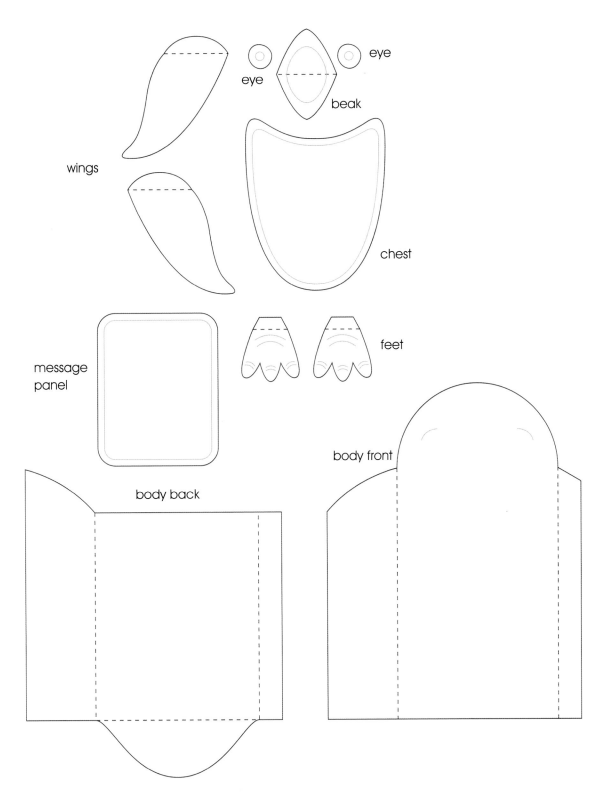

eye

eye

beak

wings

chest

message panel

feet

body front

body back

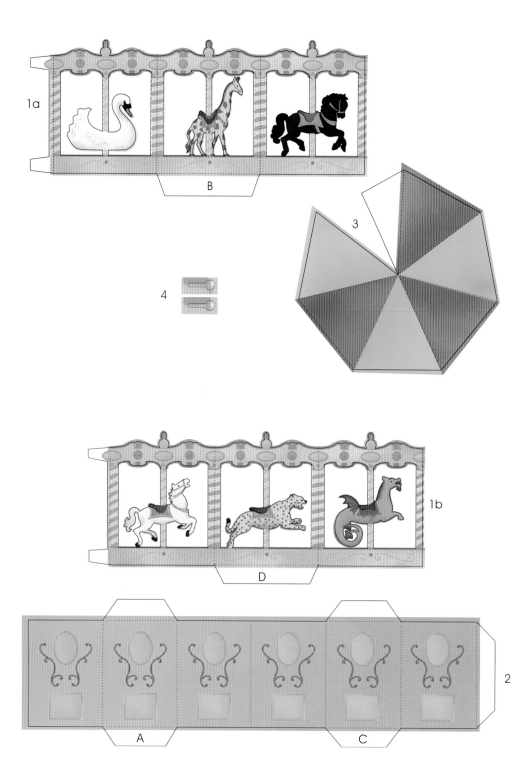

CAROUSEL (CONTINUED): page 55 (shown at 50%)

base

OCEAN TUNNEL: page 59 (shown at 50%)

sharks

OCEAN TUNNEL (CONTINUED): page 59 (shown at 50%)

coral

jellyfish

HOT AIR BALLOON: page 65 (shown at 50%)

landscape

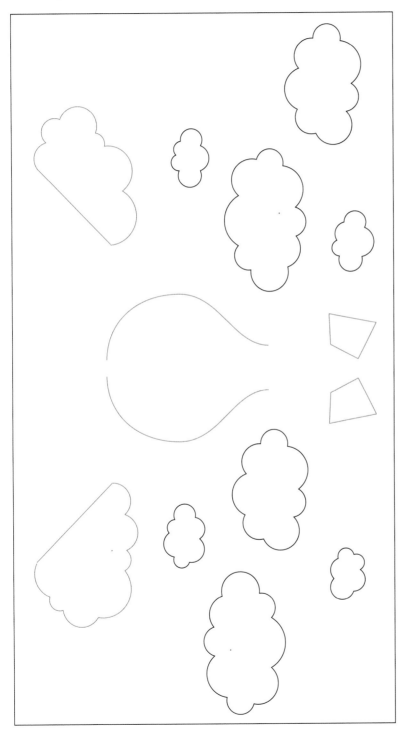

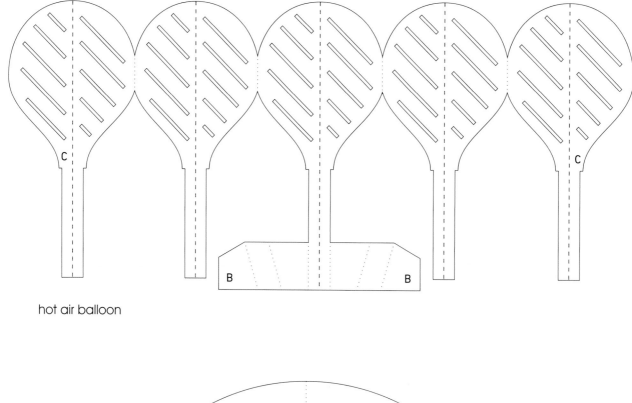

hot air balloon

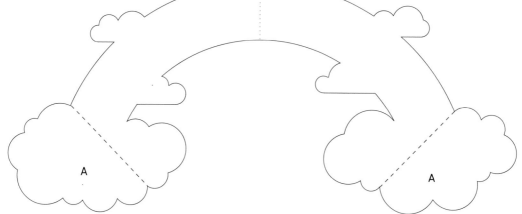

rainbow

SNAIL ON A LEAF: page 61 (shown at 50%)

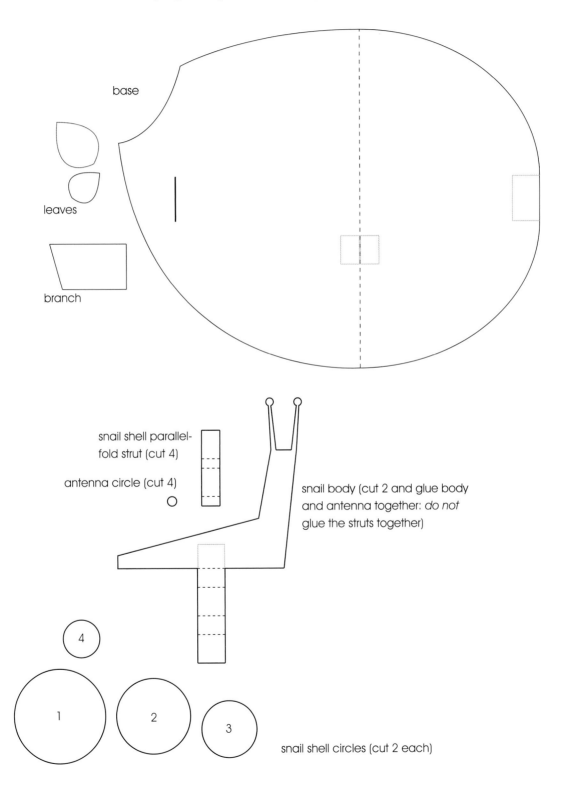

base

leaves

branch

snail shell parallel-
fold strut (cut 4)

antenna circle (cut 4)

snail body (cut 2 and glue body
and antenna together: *do not*
glue the struts together)

4

1

2

3

snail shell circles (cut 2 each)

DAFFODIL: page 67 (shown at 50%)

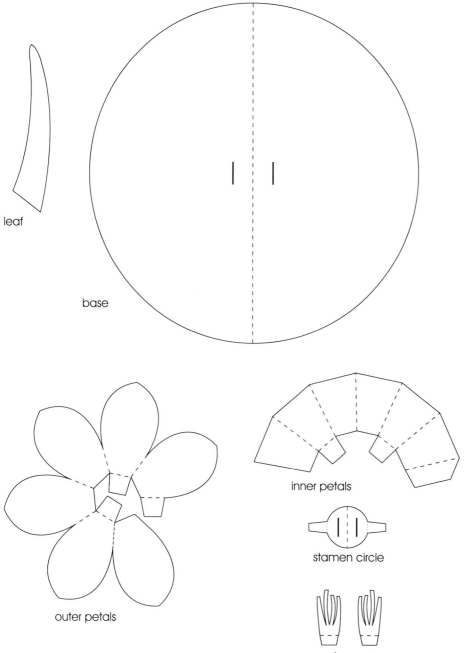

leaf

base

outer petals

inner petals

stamen circle

stamens

CUPCAKE KITTY: page 71 (shown at 50%)

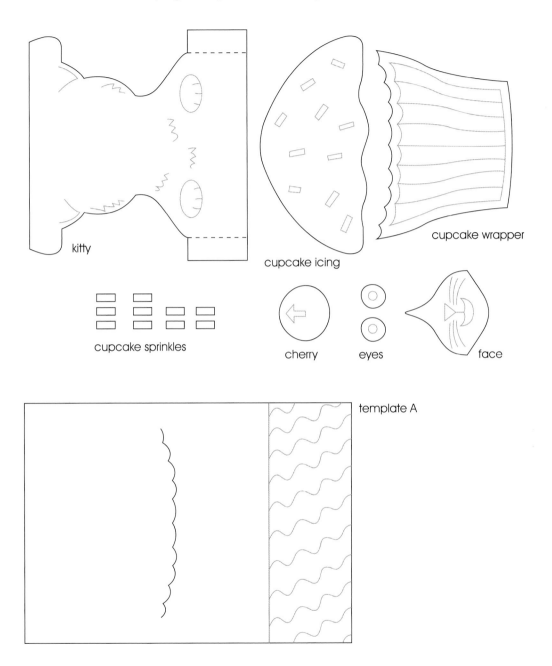

kitty

cupcake icing

cupcake wrapper

cupcake sprinkles

cherry

eyes

face

template A

LET'S TRAVEL: page 74 (shown at 50%)

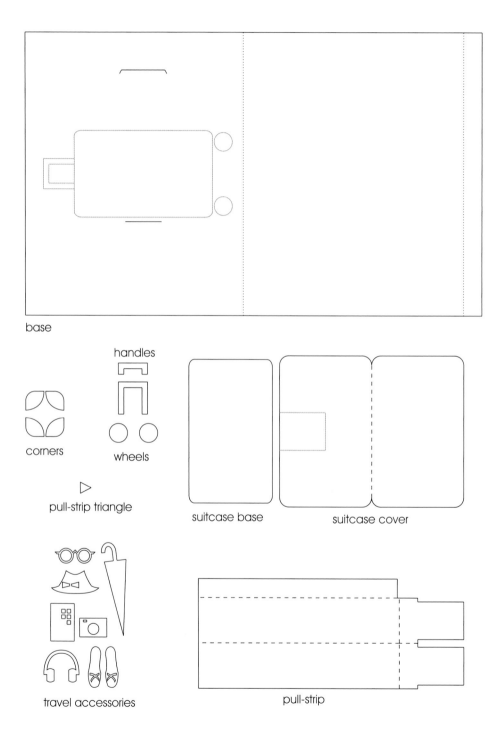

base

corners

handles

wheels

pull-strip triangle

suitcase base

suitcase cover

travel accessories

pull-strip

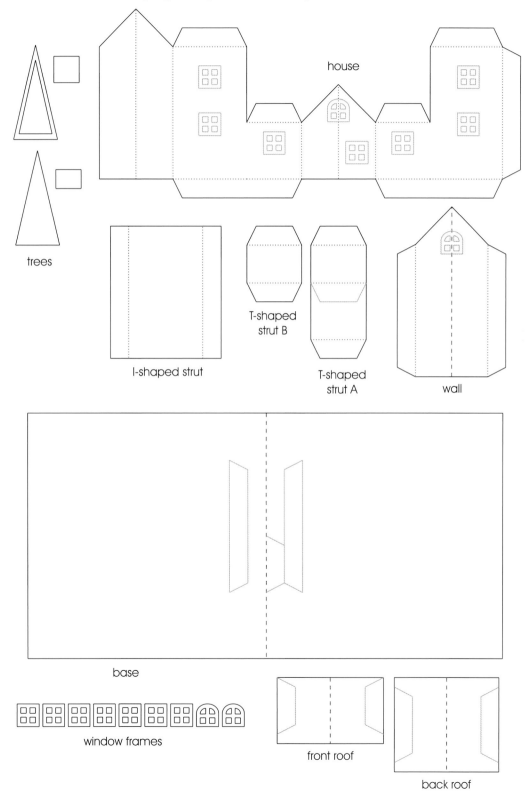

trees

house

I-shaped strut

T-shaped strut B

T-shaped strut A

wall

base

window frames

front roof

back roof

FLYING SWALLOW: page 81 (shown at 50%)

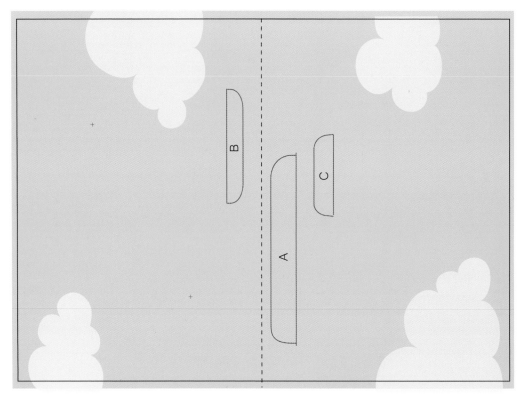

base

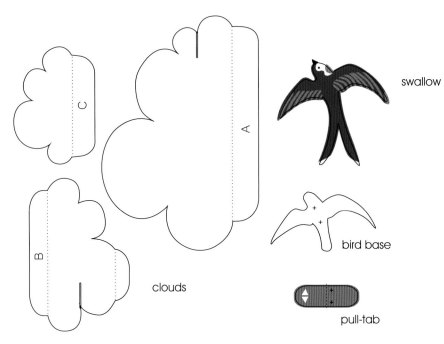

clouds

swallow

bird base

pull-tab

HEART GIFT BOX: page 84 (shown at 50%)

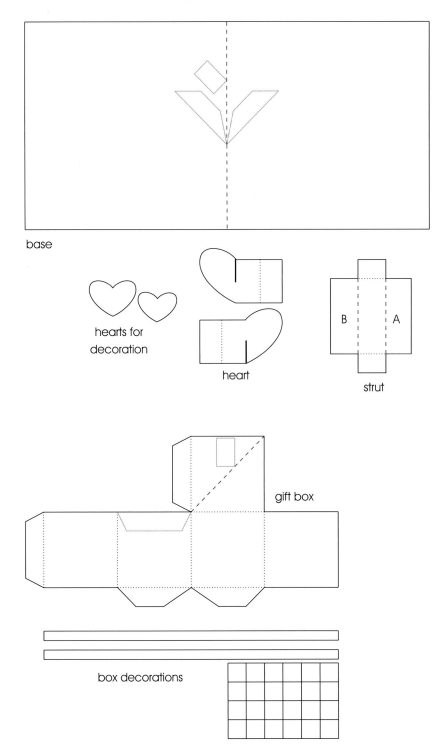

base

hearts for decoration

heart

B A

strut

gift box

box decorations

SUNDAY DRIVER: page 88 (shown at 50%)

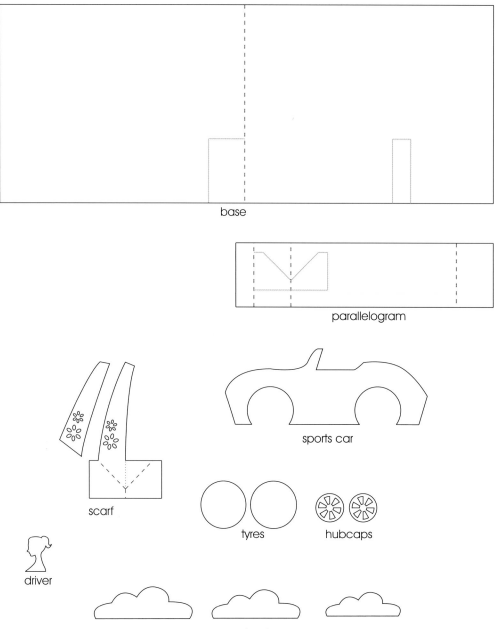

base

parallelogram

scarf

sports car

tyres

hubcaps

driver

clouds

HILLSIDE VILLAGE: page 91 (shown at 50%)

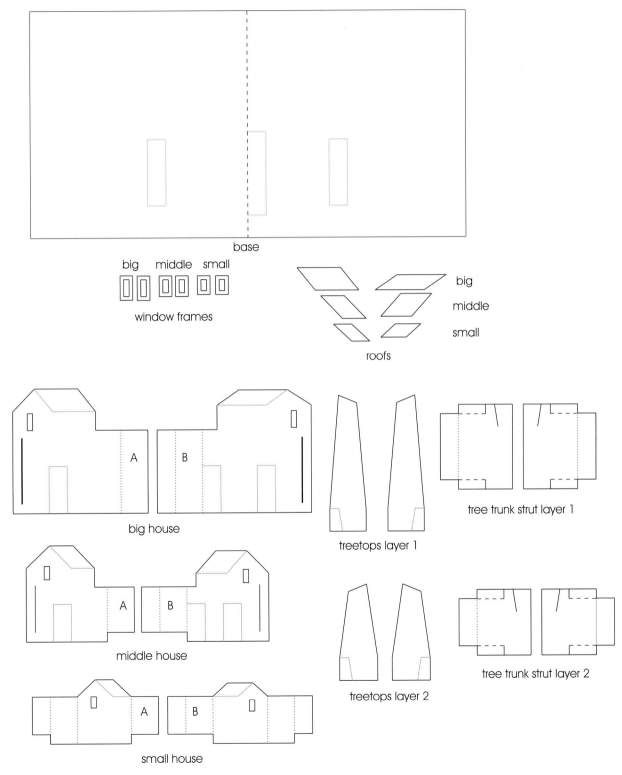

base

big middle small

window frames

big

middle

small

roofs

big house

middle house

small house

treetops layer 1

treetops layer 2

tree trunk strut layer 1

tree trunk strut layer 2

WINGED DRAGON: page 94 (shown at 50%)

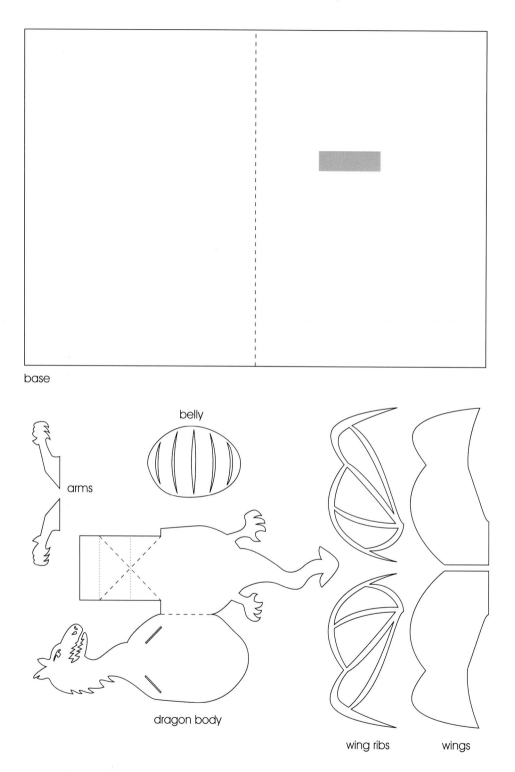

base

belly

arms

dragon body

wing ribs

wings

TINA KRAUS is a freelance illustrator and paper engineer living in Muster, Germany. She works on a range of projects, from book illustration and production to engineering for pop-ups and designing packaging, toys and objects from paper. Tina is drawn to working with paper as there are so many options: sewing, cutting, folding, shaping and painting. Her work is very precise and often includes moving parts to bring the objects to life; her paper work also features her own illustrations. To see more of Tina's work and products, visit www.faltmanufaktur.com.

FREYA LINES is a designer and craftsperson based in London. She finds inspiration in all things paper and nature, particularly leaves, seeds and flowers. Freya creates hand-illustrated surface designs, decorating homewares, accessories and stationery, along with bespoke paper-crafted works. Since graduating from the University of the Arts, London, in 2010, Freya has worked on various commissions for different clients, from greeting cards to branding, logo and website illustration. She also creates bespoke handmade paper cut works, from album cover artwork to hand-crafted wedding table decorations. To find out more, visit www.linesdesigns.co.uk.

KYLE OLMON is an American children's pop-up book creator and author. Kyle began to create dimensional artist books after receiving degrees in painting and art history from the University of Illinois. His first major project was *Celebration*, a collaborative pop-up book sponsored by the Movable Book Society. Shortly thereafter, Kyle moved to New York City, where he worked with Robert Sabuda and Matthew Reinhart for eight years. He is the author and designer of the *New York Times* bestselling pop-up book *Castle: Medieval Days and Knights*. Kyle teaches a course on pop-up design at Pratt Institute, and he is a board member of the Movable Book Society. To see more of Kyle's work, visit www.kyleolmon.com.

INGRID SILIAKUS discovered her passion for paper engineering after seeing the work of Masahiro Chatani from Japan, first spending time studying his work before beginning to create her own. She specialises in architectural paper cut designs as well as intricate abstract sculptures cut from a single sheet of paper. The work is so involved that she will sometimes make up to thirty prototypes of a design before arriving at the final piece. Ingrid describes the methods of cutting and folding to be meditative and over the years has developed an extremely high level of technique. You can see more of Ingid's paper architecture at www.ingrid-siliakus.exto.org.

MARTHE VAN HERK (WHISPERING PAPER) graduated from the University of the Arts, Utrecht, as an art teacher. After a few years of teaching, Marthe felt an irresistible urge to revisit her own creative work. She was inspired to try paper cutting by the work of Dutch artist Geertje Aalders and went on to develop her own style of incredibly delicate and intricate pictures. Her shop, Whispering Paper, is the product of countless hours spent honing the drawing and cutting skills required to produce this beautiful and fragile art form. View Marthe's work at www.WhisperingPaper.com.

ROSA YOO is a paper artist living in South Korea. She was drawn to paper craft as she finds it a simple and everyday material that is accessible and recognisable for both adults and children alike. Rosa creates pop-up cards, books, paper sculptures and miniature artworks. She has held many exhibitions and taught workshops in all these areas, and her design subjects range from food to architecture and flora. Rosa sells her cards and artworks via her etsy shop at www.etsy.com/au/people/rosayoo. You can also see her latest work and work-in-progress at instagram.com/rosaiyoo.

The publishers would also like to thank Hannah-May Almond for her assistance.

INDEX

Page numbers in **bold** type refer to templates.